KU-746-045

JOHN CAIRNEY is well known to audiences in Scotland and internationally through his one-man shows about Burns. Indeed, in many minds he is synonymous with the Bard and is considered as one of the leading interpreters of the works of Robert Burns.

In more than 50 years as an artist, he has worked as an actor, recitalist, lecturer, director and theatre consultant. He is also a published author and an exhibited painter. Trained at the Royal Scottish Academy of Music and Drama, he was a notable Hamlet at the Citizens' Theatre and a successful Macbeth at the Edinburgh Festival. He was also *This Man Craig* on television and has appeared in many films like *Jason and the Argonauts* and *Cleopatra*.

He gained a PhD from Victoria University in Wellington, New Zealand and is much in demand as a lecturer, writer and consultant on Robert Louis Stevenson, Charles Rennie Mackintosh and Robert Burns. Dr Cairney has written books on each of these famous Scots, as well as other books on football, theatre and his native Glasgow, where he now lives with his New Zealand wife, actress and scriptwriter, Alannah O'Sullivan.

Some people in Scotland regard him as a legend and a national treasure. But he sees himself as a jobbing actor and always will, as long as he can stand up and talk to an audience. As he says, 'Theatre has given me a full, wonderful and rewarding life. Now, it is payback time. Hence this book.'

for alastair
with bestwishes

John Cairney

Dr Cairney's previous books include:

Miscellaneous Verses
A Moment White
The Man who Played Robert Burns
East End to West End
Worlds Apart
A Year Out in New Zealand
A Scottish Football Hall of Fame
On the Trail of Robert Burns
Solo Performers
The Luath Burns Companion
Immortal Memories
The Quest for Robert Louis Stevenson
The Quest for Charles Rennie Mackintosh
Heroes Are Forever
Glasgow, by the way but
Flashback Forward

Greasepaint Monkey

An Actor on Acting

JOHN CAIRNEY

Luath Press Limited
EDINBURGH
www.luath.co.uk

First published 2010

ISBN: 978-1-906817-42-8

The paper used in this book is recyclable. It is made from
low chlorine pulps produced in a low energy, low emissions manner
from renewable forests.

Printed and bound by
Bell & Bain Ltd., Glasgow

Typeset in 11 point Sabon
by 3btype.com

The author's right to be identified as author of this book under
the Copyright, Designs and Patents Act 1988 has been asserted.

© John Cairney 2010

To the late Michael Williams, Actor

1935–2001

I am a persuader
Using the radar
Of my mummer's art,
Spoken lines to impart
A thought for a moment
For an audience to catch and consider;
To let the imagination
Dance to the music of the word.
Is it not absurd
That a mere player
Can take it to places it might never see
Except in the mind's eye?
The pleasure and the pain go with the ticket.
A lifetime's recollections of delight
Can be bought at the box office
Or a passing sensation
Rented for the night.

JOHN CAIRNEY – Glasgow, 2010

Contents

Acknowledgements

THE AUTHOR WISHES to express his gratitude and appreciation to the following for their trust, help, information, advice and encouragement. First place of course has to go to my publisher, Gavin MacDougall, whose idea it was that I put into print what he had heard me say so often from the platform or stage, in the car and around the dinner-table. Gavin made practical what has been recognised down through the ages that people have always been curious about the actor.

In a long and happy career of nearly 60 years on the professional stage, I have had many masters and many colleagues. It is to them, their comments and conversations, I owe all of the ideas and anecdotal quotation that may be found in the following pages, not to mention the practical help given by so many others in putting the material on to the page. There are too many to name them all, but the following may be mentioned as being of particular assistance,

David Andrews
Bill Bryden
Richard Demarco CBE
The late Sir Alec Guinness
Alice Jacobs
Jane Livingstone
The late Duncan Macrae
Freya Manners
Alannah O'Sullivan
The late Alistair Sim
and particularly Dame Judi Dench.

Clare Brotherwood
Jennifer Cairney
Murray Grigor
The late Sir Tyrone Guthrie
Lesley Johnson
Katharine Liston
The late Roddy Macmillan
David McKail
The late Sir Michael Redgrave
Dr Donald Smith

but my deepest gratitude is due
to the audiences I have known in my career.
They have taught me everything
I have learned about theatre
in a love affair that has lasted a lifetime

Foreword

I WAS FIRST AWARE of John Cairney at the Edinburgh Festival in 1959 when he and Tom Fleming both appeared in *The Thrie Estaites,* directed by Tony Guthrie at the Assembly Hall.

We did not meet until 1990 when Michael and I accompanied our daughter Finty to Greece. We went as chaperones, as Finty was only 17 and had been cast as one of the leads in *The Torch* which was filmed in Greece and Yugoslavia for Edinburgh Films. John and Alannah were in the cast as, subsequently, were Michael and I. Later on, we shared a lovely Highland holiday weekend at Eriska in 1990 before John and Alannah left for New Zealand. Their last night in the UK before emigrating in 1991 was spent at our house, and it was in our local, The Bell, that Michael suggested to John the subject for this book.

This book is the result and it is about the job we all love – acting! It tells the story of persistence against all odds because we care passionately about the work that we do.

It is a tribute to actors. You might not always know their names, but you recognise their faces when they turn up in plays, on television or in films. This book is about the sweat and tears of getting started, working under a director, nerves on the first night, facing the critics, coping with type-casting, and worrying about old age. In spite of all the angst, through it all is the inner dynamic of sheer pleasure in the work and satisfaction in the results, and, above all else, the relationship all actors build up with their audience. This, to me, is the kernel of the book and its main thrust: that theatre in the end doesn't belong just to the actor, but to the audience as well.

Judi Dench, 2010

Prelude

THE WHOLE IDEA OF *Stage Whispers* started with a simple line – 'What wilt thou, my Lord?' This might have sounded innocuous enough had it been uttered in any Shakespearian tavern around the end of the 16th century, or perhaps today in the most pretentious of London clubs, but it was actually said to me by that late and lovely actor, Michael Williams, in a pub in Surrey in 1991. He was asking me what I would have. Like all well-brought-up Catholics we had repaired to the 'Bell' straight from Sunday Mass and with the yardarm at least a whole afternoon away it was time to enjoy our first beer of the day. However, as Michael had asked me in his second language, which was the Shakespearian iambic pentameter, I attempted a reply in the same.

'A beer, i' faith. For 'tis said, that here in England, the Sabbath morn is not complete without its ale.'

'Without fail.' replied Michael immediately, 'By the Mass, the soul having had its balm, the body calls for same support. A beer, you say?'

'I do, and with much thanks.'

It went on like this for ages, with Michael coping effortlessly and me running hard to keep up until I had to call out,

'Michael, hold, enough. A glass of ale, I say.'

''Tis done. I will away.'

While he headed for the bar, I took a seat near the dart board and set myself for the delights of a sunny, May morning in an English pub.

I had halted our 'Shakespearean' exchange, not because I was desperate for a beer but because I knew I couldn't sustain it at Michael's level. All his years at Stratford and elsewhere had given him a love for the Bard and an easy assurance in the delivery of the standard line as it might have come from any of the plays. He revelled in Shakespeare's timeless rhythm. I had a young Hamlet under my belt, and a middle-aged Macbeth, not to mention assorted Shakespearian casting over the years but I was no match for my morning companion's broader bardic experience, or indeed his wider, practical appreciation of the whole formidable canon. This gave him a rare insight into the essentials of drama, at least as the Bard of Avon saw it. As Michael said, 'Let's face it, Shakespeare's said it all, hasn't he? And if other writers have said the same thing, so what? He said it better.'

'I wouldn't argue with that. Here's to the Immortal Bard.'

'Cheers.'

Over our beers, Michael and I talked much as all actors talk, that is, with a love of the spicy and the humorous, hinged on the personal, but not entirely egotistical. Michael Williams was much too diffident a man, and genuinely modest, to be vain, but he knew how to cast himself as story-teller and he had every actor's love of the anecdote – especially the delicious sort that deals with the performer's predicaments on stage and their often hilarious consequences.

Stage talk, or greenroom gossip, is a conversational genre all of it own. It's rarely barrack-room bragging or cocktail party innuendo. It's full-blown, Rabelaisian bluster delivered with gusto, and enjoyed by the speaker as much as his audience. If it is personally-based it is likely to be self-deprecating. That's a safer way to win the listener and help steer the speaker away from the exhibitionistic tag that dogs the actor of what-ever type or nationality. In my experience, and I go back a bit, the greater the talent, the less histrionic the off-stage personality. Quite rightly, and if only for self-preservation, the real actor keeps 'exhibitions' for the boards, where they belong, and for which he is paid. Unlike the second-rate performer, he is unlikely to be seen or heard giving second-rate per-formances for nothing at dinner tables or even in conversation at the corner of a bar, but Michael Williams was no second-rater.

I couldn't help noticing that while our fellow patrons at the 'Bell' enjoyed his presence, and knew well who he was, they gave him a regular's privacy and didn't bother him. That's real respect. He was *liked,* so he was left alone. This is unusual. In any gathering the actor always seems to be the stranger. The ubiquitous enquiry to someone met at a cocktail party or dinner. 'And what do you do?' Generally delivered with the eyes already looking over your shoulder and one ear on the nearest conversation, the polite enquirer rarely expects to hear 'I'm in the theatre,' and one can see the eyes whip back in reflex. The questioner is now interested and follows up with, 'Oh really? Should I know you?' This is the normal assumption that all actors should be famous. This is not always so. The journeyman actor doesn't worship at the Court of Celebrity. Fame is something thrust upon him, if it does happen, so he learns to live with it and take it as a compliment to his work and not to the person he is.

Michael Williams was such an actor, and such a man.

I was due to go off to New Zealand the next day and was planning a book on *Solo Performers* for an American publisher. I very much wanted to include Michael, because of this very quality of likeability, mandatory for any soloist. The audience must sympathise at once with the soloist or they will never go the distance with him. And there is no longer journey for both actor and audience than the two hour traffic of the stage when one party in the act is uncomfortable with the other. Michael exuded stage ease and won houses over with, apparently, the very minimum of effort. He was the perfect solo player (as he was later to show as John Aubrey) because he was of that rare breed that found no difficulty in filling the stage with his presence.

At that time, however (May 1991), I was trying to persuade him to play Rob Wilton, the famous English North-Country comedian, who was also, like all great comedians, a superb actor. I could just see Michael bring off the earthy, kindness of the man and in that voice that was so near his own Lancashire roots. To my delight, and the amusement of those around us, Michael actually gave us a 'Wilton' moment there and then, in the 'Bell'. I can still see his hand wiping itself around that amiable, elastic face as he uttered the famous Rob Wilton opening lines as heard on the wireless, as we called it then.

'The day war broke out, my Missus said to me, "What are you going to do about it?" "About what?" I said. "The war," she said. "I don't know. I didn't start it…"'

And so on. We all wished he had gone on. Unfortunately, for one reason or another, he never got to play his fellow-Lancastrian, and I regret it to this day. Not only would it have been a striking piece of theatre, it would have been an important entry in the Solo book. However, while we were talking of that, he said,

'Why don't you write a book about us?'

'What do you mean?' I asked.

'A book about actors, ordinary actors who spend their lives in the theatre. Not the stars, the big boys, the celebrities, they can write their own books .

'Or have them written for them,' I put in. 'Half the Amazonian rain forest has been given over to books about acting.'

'Or a touch of the bios,' added Michael. 'Everybody's done that. No, I mean something about the kind of performer we both know. Quiet and

ordinary off stage, but 'on' they give a performance that's right on the button. Bloody good actors, all of them, yet nobody knows them. They might not have made a name for themselves, but they made a living. And had a good life of it. The old-time rep performer, the everyman actor. Know what I mean?'

I knew exactly what he meant. We had so much in common, Michael and I. Both working-class, big-city, grammar-school boys who, to their surprise, found theatre, or did theatre find us? Michael came from that English Glasgow called Liverpool and I came from the Scottish Liverpool called Glasgow. However, we both knew the repertory actor type well. They're almost gone now, swallowed up by television and a few days in a film now and then, but once upon a time they were the backbone of every decent theatre company in the country. And there were lots of theatres then. They're forgotten now, of course, but that doesn't matter, the actors who played in them, week in week out, had their hour, you might say. and you can bet they grabbed it.

Each of us knew, too, the last of the great and glorious, repertory days in British theatre. A new production every three weeks, audiences packed with typists and school teachers (nurses free on Monday nights, pensioners on Saturday matinees). Great classical plays with huge casts supplemented by students and local amateurs and crowds at the stage door. All of this was pre-TV, of course, and pre-Bingo, it was another kind of theatre in a different time. We were both fortunate to know this golden age of greasepaint before the shadow of home entertainment fell over it. Yes, I knew exactly the kind of actor he was talking about. They were English colonists who brought the West End to every provincial theatre in the country and converted so many to the stage. These missionaries in motley weren't stars but they shone brightly with what is still called talent.

Michael and I talked of men like these and wondered where their kind was in the technological climate of contemporary theatre. Of course, actors of the type like the pre-television practitioners are still there. Great actors, like great footballers and great singers, emerge in every generation. That's a fact of cultural evolution, and no one can be other than of their time, but, Janus-like, the great ones, as all real artists, look back to previous eras and, simultaneously, to future generations.

Our talk that day was along these lines, a pleasant mixture of

recollection, observation and appreciation of the gods of our youth. Deep down, as Michael pointed out, they were ordinary flesh and blood men who stood up to be counted when it mattered – when the house-lights went down and the stage lights went up. In our early days, we had stood behind these actors as virtual extras in the nightly ritual, watching them as they took us, as well as the audience, to Parnassus. At just the right moment, they seemed able to reach up and touch the stars.

We thought, this is what it must be like to be an actor. It was hard to remember that just that morning the same men were in tweed jackets or turtle-neck jerseys, sitting in a broken-down armchair in the green room with a cigarette in one hand, a pen in the other and the day's cross-word on their knee. They knew at all times that, however little distance they may get in their chosen trade, they would get far enough to survive in a reasonable degree of comfort.

As we talked the minutes flew. We each quoted our instances and gave our examples as yet another beer went down and another cigarette was lit. We came to the agreement that the chorister, acolyte, vagabond, moun-tebank, buffoon, stroller, travelling gypsy having been with us now, under any or all of these titles, for nearly 3,000 years, should be remem-bered. The actor was actor whatever his time. He was of all time and his story should be told.

By this time, our lunch at home was getting cold but the actors we were talking about grew taller and more magnificent with every word and the actresses more beautiful and beguiling. Even the incidents mentioned were becoming funnier. Like Edmund Kean, who, on being castigated by a Glasgow audience for being drunk at a matinee of one of the histories, swayed down to the footlights and boomed out, 'If you think *I'm* drunk, wait till you see the Duke of Buckingham!'

Or the Method actor who went to extremes in preparation for every part. When cast as Long John Silver in *Treasure Island* he insisted that he should have a green parrot.

'I've only got a yellow one,' said the pet shop man. 'Wouldn't that do?'

'No. It must be green,' replied the actor.

'Well, come back in a week and I'll have your green parrot.'

'Good.'

'Right. I'll have it here for you next Monday. OK?'

'Next Monday?' asked the actor.

'That's right.'

'That's no good.'

'Why not?'

'I'm having my leg amputated that day.'

The stories went on, until, just a little unsteadily, we rose to go. The last toast was given by Michael, 'To the Unknown Actor, ' he said, emptying his glass.

'Hear! Hear!' I said, doing likewise. Then I asked him,

'What about the Unknown Actress?

Michael thought for a moment, then grinned. 'We're all one under the greasepaint, don't you think? Anyway, who was it said, "Scratch an actor and you'll find an actress?"'

'Wasn't it Dorothy Parker?'

And that was it. We put our glasses down on the bar with a satisfied clunk and moved to the door past the waving hands of the remaining customers.

As we moved to the car, Michael said, 'And by the way, we don't want another act-tract either. We've been preached at this morning already.'

'As you say, Michael.'

At the time of writing, it is 20 years since that lovely Sunday morning but the book Michael and I talked about is now in your hands. It is offered now as a tribute to the unknown artist-artisan-actor, who, in every theatre, everywhere, is humanity's spokesperson, *acting for all of us,* then and now, and continues to do so, serving the drama which in the theatre is the living repository of everybody's heritage.

Why this is so is the mystery these pages will attempt to fathom.

Prologue

'... before when, by a generous public's kind acclaim
that dearest need is granted, honest fame;
where here your favour is the actor's lot
not even the man in private life forgot'

Spoken by William Woods at his benefit night at the
Theatre Royal, Edinburgh, 16 April 1787

'EARLY DOORS' IS SOMETIMES used as a euphemism for actors who died young. Early doors were the admittance to the gallery and the cheaper seats well before curtain up allowing them to make the long climb to the Gods. This then was taken to apply to young actors who made their way to God prematurely, hence, 'early doors'. In this case, however, the title serves to indicate a kind of Preface, an opportunity to expand on what kind of book this is meant to be, and for whom it is intended.

First of all, this is not a book for those who go at once to the Index to find they are not in it. For one thing, there is no Index. There is no need. There are no 'names' in this little tome. This is a book about actors and acting, not a name-dropping exercise. Nor is it a *How To...* book for would-be actors, nor, I hope a *When I was...* book by a has-been actor, but rather a *Why it is...* book by someone who wants to pass on to the average theatregoer and anyone else interested in theatre what it *feels like* to be a professional actor. It is about what actors do, and have been doing for almost 1,500 years, as they go about their business of pretending to be someone else in public for money. It is an actor's view of his own world, of the audience, of critics, from the inside, a peep behind the mask by someone who's worn it, a look again backstage and into the rehearsal room by one who's spent most of a lifetime there.

The concern here is not with the great stars, or leading performers or performances, but with un-public doings of the rank and file artisans of the histrionic trade, without whom the said stars could not shine, nor could any play be possible. These greasepaint stalwarts are the backbone of theatre. They are not bit players or extras, but solid performers, proven journeymen and women who can fill out a character intelligently and not without talent, and manage in the course of their careers to pay

their taxes, buy a house and send their children to university. In short, they are sound professionals.

Who better than they to investigate the theatre paradox, where part and person mix in a combination of truth and prevarication? Who is more entitled to define the mystery behind the mystique of their craft or to understand its power over an audience? As the actor's every act on stage is for the benefit of that audience, so this volume is aimed at enhancing and filling out the theatregoer's enjoyment of the theatrical experience.

For the sake of clarity, and remembering Michael's comment, I shall refer to my actress colleagues here by the generic term 'actor', in accordance with modern usage, loathe as I am to discard that lovely word 'actress'. However, it was noted by Sheridan in his Epilogue to *The Rivals* in 1775.

Through all drama – whether damned or not –
Love gilds the scene, women guide the plot.

It is accepted today that acting is neither the preserve of a fraternity nor the exclusive property of a sorority but what they have in common now is actorship, a resort of the universal histrion. Their mutual business is to engage a group's attention in a given place and hold them there for a given time, releasing them to return to the other world that is outside the theatre doors, trusting that they are better for having spent the afternoon or evening in the company of actors.

What is basic to the whole enterprise, and essential to its success, is that the audience has assembled willingly and has paid good money to watch painted people, dressed in funny clothes, pretending to be someone else in another place, and finds these same imitators, *at the time of performance,* completely believable. This is the suspension of disbelief that is the real mystery, and at the heart of all acting and the following pages will expand on this. The actor creates a make-believe world of his own but it is only justified if it is shared with an audience at that 'intersection of the here and now', to quote Paul Taylor's memorable phrase.

The art of the drama is always in the present tense. Its act is NOW. That is its magic, and why it's so often memorable. Fashions may change from generation to generation, styles of acting may vary, names will change from season to season, but essentially, acting itself, the engagement with the audience in the NOW, remains the same whatever the time or place. The actor burnishes the scripted lies in rehearsal and offers them to the

audience in performance, which then polishes them further by absorption and takes them home at the end as memories.

This is the business of theatre. So much of its night-to-night image is ephemeral but its basic verities are constant. The demands it makes on both audience and performer are different. Disbelief is suspended in the theatre in a way unique to itself and not at all the same as when the performance is seen on a screen. First of all there is a huge difference in technique. The performance to camera is built up by a non-sequential aggregate of captured moments, whereas the stage performance is delivered in one continuous sweep of the hour hand in the course of the whole play. The screen actor picks at his food, the stage actor swallows it in one big gulp.

However, the final intention is always the same, to satisfy the audience's appetite for sensation, that feeling brought about by reaction to a re-enacted event presented to it in performance. Film acting may be described as hours of boredom broken up by spasms of anxiety justified by flashes of insight. Stage acting is to stand at the foot of a mountain and know that the first spoken line is the first step on a long climb. It always looks a long way up from the bottom. Even though rest camps are provided at intervals, it takes no little courage to commence on such an ascent. Acting is first and foremost, a physical challenge, and no small one in terms of stamina, voice control and memory.

Its purpose is to bring the audience into the world the *performer* is creating at that time by inhabiting the script and conveying to an audience by action and the word the dramatist's vision. Even with the finest script, the most detailed production and a wealth of acting talent on display in front of a sympathetic house, there is no guarantee it will work every time. That's its challenge, its fascination, but it's also the reason why so few actors are smug. They can never be sure about getting a job in the first place, and when they do, they can never be entirely certain they will do it well. There are so many variables, but then that's what this book is all about.

Hundreds and hundreds of thousands of unknown theatre performers all over the world, in big-city theatres, village halls, tents, sports grounds, park pavilions, hotel restaurants and wide, open-air spaces have trembled in whatever serves as 'wings' before stepping into the spotlight and uttering that terrifying first line. This book is theirs, it

belongs to the anonymous soldiers of a vast army enlisted to serve in that great crusade of the human spirit known as the drama, in its many forms, ancient and modern.

The actor has walked a long road over the centuries and for much of the time it was rough going. In medieval times, the bearward gave way to the stroller who ceded his platform to the common player of interludes, who, in turn was replaced by the counterfeit Egyptian or petty chapman or any guise that would earn a penny in the market place. From 1632, a licence had to be sought from the authorities under pain of a good whipping, and if not obtained, all players were deemed rogues, vagabonds and sturdy beggars and threatened with a lengthy spell in the House of Correction. Play-acting was not a soft option, yet it has survived plagues and pestilence, wars, revolutions, closures and exile to become the sport of the fashionable and the study of the learned. Its practice has attracted minds of quality and probity, and men and women of great physical beauty as well as every scoundrel that ever chased a dishonest profit. If acting is indeed 'a mirror held up to Nature' then it needs a good cleaning now and then. After all, it is a very old mirror.

Theatre may be the place where the Devil gets his due, but it lives, as people live, for the passing hour and is justified only in its living moment. Emotion can be stimulated by the swirl of a cloak or the flourish of a hand, but the same cloak hides the real emotions of the actor wearing it and this personal dichotomy has always to be borne in mind. As long as people will gather to witness, the actor will perform, and the stage will have its upholders. As Charles Lamb said in his *Popular Fallacies* of 1826,

A man might blur ten sides of paper in attempting a defence of it.

A side was the old name given to the pages of the actor's individual part as opposed to the whole play script. Actors up to Victorian times were often cast in a part by being given only the sides for that part, without ever really knowing what the play was about. They were expected to pick that up in rehearsal. It was felt appropriate in this little book, if only as a little conceit, to use the term as a chapter heading if only to honour all those who were handed their 'sides' on the first day of rehearsal.

The term 'side' also serves as a metaphor not only for the actor but for every human being who plays his or her part as cast in the world without really knowing much about the 'play' as a whole or why they

are in it in the first place? Like the actor, they are expected to pick up such information as they go along.

The thing is to enjoy the journey and its starting point is the first read-through of the intended play by the cast-to-be in the presence of the director and stage crew. Most professional plays begin with the read-through. Usually held in the theatre, sometimes on stage, the actors are seated round a table along with the dramatist (if living), the producer(s), director, designer, stage management and such friends as might have influence with the producer. Generally speaking, however, this is a strictly closed shop for the actors and those off-stage, fellow-professionals who will lend their considerable talents in putting a group of vulnerable personalities on stage. Whatever the play, its period or theme, comedy or tragedy, there is always a party atmosphere at read-throughs. This is because most of the actors gathered are basically relieved to be in work, which is why a slight hysteria prevails. There is also a degree of apprehension. Actors have been known to be fired after the first read-through, although it is rare. Nevertheless, there is a tension.

On this first morning, however, when a gaggle of mostly strangers come together to make a play for the stage, it is theatre with its public mask down, and it belongs to the actors alone. For them, no matter how experienced, it is a starting again from scratch. Every new part is a beginning. Every new character is a return to base because every actor is at heart a character actor. He or she is, of necessity, at the ego-centre of their existence, if only because they are not only the result of their own work, they are also the workshop.

The leading players may know each other from previous shows but many of the supporting cast are meeting for the first time. Their over-loud voices and too-ready laughter betray their nervousness. The stage manager calls everyone together and the director of the play speaks to them, as it were, from the top of the mountain which is usually at the top of the table. A polite welcome is given to everyone assembled but most present are quietly glad to be in the welcoming arms of that old harlot Mother Theatre again, and out of the rough workaday world for a spell. Yet their play-world can be as rough and ready as any factory or workshop as the next few weeks might show, but meantime, everybody agrees with everybody about everything, and all talking at once, they take their places at the long table. They know that such utopian compliance

won't last long, so they make the best of it. There will be a lot of heart-felt catching-up in the pub afterwards.

Meantime, they gather round to admire the model of the set and the costume drawings laid out for their inspection. They make appropriate noises although few really take it all in. The stage manager then calls for silence. It falls, and all eyes turn towards the director. That potentate of the morning smiles and says, so very politely,

'Well, ladies and gentlemen, shall we begin?'

From here on the actor retreats more and more each day from the real world and begins to populate that other country where the actor and actress share citizenship, that mapped-out, distinctly different environment that is called the rehearsal room. It might not even be a room. It is the particular environment set out for the performer to find his other self, the part he or she has been cast to play. Much can happen in that bridging process called rehearsal, that wonderland or purgatory between the putting down of the books and the donning of the costumes. This is the actor's play-room where behaviour can be fittingly infantile, or the haven where refuge is found from all the crowding uncertainties. He is himself at rehearsal. He can clown or cry, lose himself in laughter or rage in frustration because he is among his own. He can make a fool of himself in the common pursuit – the co-operative project that is the making of a play.

'Half-an-hour, please!'

This is the call that rings through the backstage corridors of every theatre exactly 35 minutes before the curtain goes up. It is not half-an-hour to the actual curtain-up time, but to 'Beginners' which is the five-minute call to be in position for those who begin the play. The half-hour call is the warning to all actors and actresses in the building that they should be at their dressing-room places getting out of their coats and street attire ready to get into whatever costume has been set out for them. Besides the practical requirement to get 'dressed for the part', there is also a symbolic meaning in this, almost a rite. The actor needs to throw off the outside world prior to entering into the special world of the play. Each has to try and gradually enter into themselves, as it were. In effect, turn the outside in, emptying themselves to make room for the character to be played. This is kenosis, theatre style.

All actors and actresses must hang up their private concerns with their coats, and fold away such personal problems as all might have, whether mental or physical, with their trousers, skirts, shirts, or tops, boots or shoes, socks or tights thus making themselves free to become someone else, or rather, *appear* to become someone else, for the evening or afternoon as required. It is part of the process in helping them to get ready for the night ahead. Each pre-occupation is folded away neatly with each garment so that by the time he or she is down to jock-strap or bra and pants, the private self has been completely emptied of his or her street personality and everyone is ready to take in the characters they have been hired to play.

Each sits at their dressing-room space ostensibly exchanging the gossip of the day. All actors love gossip but, with every succeeding stroke of the greasepaint stick, or slap, as it is more commonly called, they gradually give themselves up to other priorities, that world of pretence they will combine to populate with their colleagues for the benefit of the audience they can now hear chattering through the dressing-room tannoy. Not for a second do these buzzing outsiders give a thought to the performers, who, at that same time, are getting ready to go to work, but that is just what they are doing as they sit staring into the mirror and painting their faces.

For the theatre artist, getting into costume or stage clothes is just the same as any artisan getting into his boiler suit or overalls, the technician putting on his lab coat, or the lecturer donning his gown before facing a class, although it is unlikely, one hopes, that any of these will redden their lips or put on a full-bottomed wig. Even if there is no apparent change of costume other than the changing of modern street clothes for modern stage clothes, the fact remains that the dressing-room costume change is a remarkable metamorphosis, and it happens nightly and often twice on matinee days.

Some actors have been known to go home in their contemporary costumes although this is frowned on by the wardrobe department as the same actors have been known to come back next day with the traces of last night's after-show supper on a lapel. Only irresponsible actors would dare act this way, responsible actors would not. They know they can't walk off the street and straight on to the stage. A period of transition is needed and taking off one set of clothes and putting on another is as good a way of effecting that mental changeover as any. Some performers, however,

seem insensible to this requirement. One insouciant thespian strolled through the stage door late to be met by a panic-stricken stage manager,

'Sir –, you're on!' Meaning he's 'off'.

'Oh? How am I doing?' replied the imperturbable knight of the theatre and, handing his cigar to the anxious stage manager, walked straight on stage leaving a trail of expensive cigar smoke behind him. Not all actors are as unflappable – or egotistically eccentric.

The average actor knows that any day-to-day concerns, like income problems, that row with a partner, the dreams of a new house, hopes of the next job, whether or not a change of agent is called for, whatever it is that's the current vexation, will not go away. These naggings will come out again when re-dressing at the end of the show, but in the meantime, the suspension of disbelief is a phenomenon that not only applies to the audience. It is not that the actor *becomes* that character. That is impossible. It is the appearance of being that is sought for, hence the importance of costume and make-up. These, however, are only aids towards an end.

The irony is that the play being worked on is often an escape from the preoccupations of the outside world, as much as it is a brief imprisonment in pretence. This being said, the inside world of theatre is no cocoon. It makes its own demands and exerts at times a greater discipline on its adherents. The self has to be seen with a larger eye much in the way an artist sees his canvas or the musician his score. In both worlds, the search is imperative. Every effect has its price. Nothing is for nothing.

Yet acting is more than a superficial demonstration for the benefit of the onlooker. What the actor does is to assimilate the exterior of the character as written and allow it to fill the interior space left for it in the mind so that the imagination is given room to play. Something is always needed to trigger it off.

Sometimes, this can happen by being given just the right pair of shoes, or exactly the jacket that the character might wear. The fit tells the actor something at once and with it might come the voice needed, or the walk that would be just right. The performer seizes on any little trait that can be put to the service of the lines learned, and will take help from anyone or anything that assists towards a more effective performance. The ideal sought is where internal technique and external assists combine

to offer the audience an 'honest' portrayal which *is* despite the obvious falsity of time and place in its presentation.

Actors will often sit at their mirror space in the 'half' going over their opening lines, muttering them quietly as powder is applied to an already-perspiring face. This is the actual way most actors prepare, contrary to whatever Stanislavky says in his iconic book. Or should I say, Lee Strasberg? It is a very practical routine, completely utilitarian but necessary. What they don't do is give thought to the mindset of the character to be played. There is no time now to re-think or search for new feelings. All that sort of work has been done in rehearsal. All that remains now is to get on with it – literally.

Yet even these practical deliberations can be disturbed by unexpected and unwelcome pre-show visitors, extra notes from the director, or a bad joke a colleague insists on telling. Every dressing-room has its clown. However, even the company comedian grows quieter as curtain time draws nearer. Everyone tends to become mute and more introverted as the clock ticks on and the 'Quarter' call is succeeded by 'Five Minutes'. Dressing-room chat does go on and will cover anything from the day's big events to the little backstage rumour that fuels all theatre gossip, especially the previous night's post-performance adventures, but as 'Beginners' draws nearer, the trivia becomes more desultory as each face at its mirror space goes further into itself. The decibel level in the dressing room noticeably drops and soon it is a palpable, monastic quiet.

Each mirror needs to concentrate in order to bring out from the self the energy that is going to make the character being played come alive, that is, to make the assiduously swotted lines seem spontaneous and the well-rehearsed moves look natural. It's all in the seeming. The actor, especially on first nights, knows he or she won't feel their own legs for the first couple of minutes but hopes that they will hold him up long enough until they feel the audience is believing what it is hearing and accepts what it is seeing. Most audiences are quick to decide whether an actor is to their liking. If not, then that particular Equity member is in for a long night. This is yet another reason for being nervous.

Inevitably, the moment of truth arrives. It is an odd expression for what, after all, is a project that is nothing less than one huge fib. This is the essential paradox of theatre, that it proffers a truth by means of an elaborate sham. Grown men and women putting on funny clothes

pretending to be other people in an imaginary world dreamed up by a third party and accepted as wholly real by people who pay for the privilege of being knowingly fooled. Put this way, it seems silly, yet why is it that it can so often create magic? Why is it that everyone admires good acting, and recognises it at once? It may be because it is a live experience that one enjoys as it happens. In another sense, it is the physical embodiment of a dream state, but most of all, it is because the great theatrical experience doesn't belong to the actor at all, but to the audience, individually and collectively. And simultaneously. That's its magic.

We have all known those moments in the theatre, when time stands still and we are in possession of a mystery that bites deep into our consciousness and touches the soul. Even if it's only a lump in the throat or the release of a hearty laugh, good theatre is capable of stimulating a response and/or creating an emotional reaction in those who attend in the moment of performance. No matter the convention required the essential *act* remains. That is, where people assemble at a certain point in expectation of observing other people going through considered motions for the pleasure and entertainment of those who have met for that purpose. It's as basic at that, and as fundamental. And as wonderful.

The human voice through the medium of the actor speaks to all sorts and conditions of people making them as one in the process. It's a large duty. It calls for no small commitment on the actor's part. One slip, one whiff of presumption on the part of the performer and the spell is broken. The real world gets in and in its brash way overwhelms the delicate filigree of the world that had been built up by the team on stage. Sometimes it's hard to get it back again. It calls for renewed effort on the part of the performers and requires the will of the audience to want it back. Theatre is a two-way process. Each party to the contract only gets back what he gives. If there is a profit at all, it is shared, that's what gives the exchange its value. That's what makes it worth working for. Fighting for.

Every actor is a soldier in Equity's army. The union card is given on enlistment and is carried proudly, or should be, by every man or woman in the day-to-day battle it is to keep in work in the theatre. There is a collegiate comfort in knowing that on every first night they will go over the top together (but not in the theatrical sense), these comrades in arms sitting at their mirrors now. They will meet again with different eyes when they meet 'on the green' as they call the stagecloth. The military analogy

is not to make the stage career seem a matter of life and death, but it is certainly a lot to do with living and dying for a chance to work.

The necrophilic metaphors are plentiful. For instance, actors try not to look into each other's eyes on stage. That way, the actor 'corpses' or laughs, killing the scene dead. Each actor learns to look at the tips of noses, which to all intents and purposes becomes the heartfelt gaze between lovers that the audience sees. What is looked at, however, and studied closely, is how the good actor works. Standing there on stage with the big actors teaches the small actor more than any diligent term at an acting school. The beginner can see the way the leading actors take command on stage. The better ones really do lead from the front. The lesser ones rarely budge from their spotlight and hardly look at the supporting actors' faces, never mind their noses. But lesser actors only rarely become big stars. Really good actors can't help it. These gifted thespians are the real theatrical heroes. Most are commissioned in the field, in the heat of action and not in some publicity agent's office. They are the gallant captains in the acting army, the senior brass stay behind the safety of their desks like real generals do, but the supporting casts are the vital NCOs and other ranks. No war of any kind could be fought without them. Not that theatre is a battlefield exactly, but it is true that every job is called an engagement.

Stars do the same job at the same time but they live in a different world from the ordinary jobbing actor. They also have a greater responsibility. It is they, generally, who bring the audience in, but that applies more in commercial theatre than in company theatre where the group is the attraction. Everybody loves a 'name', however, and these are sought every time a play production is considered. Even so, no matter the name, Hamlet still needs the second gravedigger and a Norwegian Captain. A good ensemble leaves no room for the soloist. It must be remembered that the whole idea of 'stars' arose long before MGM assembled its own Milky Way in Hollywood.

The old actor-managers in the 19th century rewarded a particularly good performance by one of their company by having a star fixed to that performer's dressing room door for the duration of the play's run. Thus was good work recognised and that player was known by his 'star'. Nowadays, one can become a star by mere habit or familiarity, like presenting the weather forecast on television or surviving in a 'reality' programme. Yet what greater reality is there than that feeling imparted to

an audience in the theatre by a good actor up on stage. The ordinary actor dreams of getting that star on his or her door, however figuratively. Until then, they slog away, taking each part as it comes and hoping the next one, or the one after that will point the way to fame and fortune.

Then, at the given time, all is ready. All that can be done is done. If not, it's too late. Remorselessly, the first night approaches.

Stand by, please.

As soon as any actor or actress steps on to the stage, they belong to the audience. They give themselves over to the moment readily but as the time for action approaches they begin to question themselves as the time ticks relentlessly by. However poised and confident they might look, don't let it fool you.

Meantime, the actor listens for that name on the tannoy, and when it sounds out, the mascot is touched, a deep breath is taken and, leaving the dressing-womb that has been a shelter for the last 35 minutes, the long walk is taken down however many flights of stone or steel stairs and along the narrow corridor through the Fire Door and into the darkness at the side of the stage. Standing there, the no-name actor is no different from the star. His heart beats just as fast, his palms are as clammy, and, at this crucial moment, the difference in their salary or status or fame matters damn all. They are companions of the moment, and together they answer the call. 'The actors are come hither, my lord,' and whoever and wherever they are, they should be welcomed. For they have come to tell us about ourselves.

What is an Actor?

HISTORICAL ASIDE

560 BC – Thespis the Greek steps out of the Chorus in Athens to become the first actor during the celebrations of Dionysius, the God of Wine and Fertility. 534 BC – Thespis awarded victor's laurels at first Drama Festival. 490 BC – Aeschylus writes first play, 'The Suppliants'. Solon calls it 'a dangerous deception'. Plato isn't sure about the 'lie' involved. We have critics already. 240 BC – Rome discovers first 'name' actor – Quintus Roscius Gallus, commonly known as Roscius. A freed slave he makes a fortune unlike Aesop, the tragedian, who takes to writing fables. In the Dark Ages of the fifth-century, theatre cannot find real expression and the medieval actors, as minstrels, jongleurs, mimes and acrobats, take to the road throughout Europe to look for it. Trailing their carts behind them, using them as portable stages, they move from place to place, taking their audiences as they find them. They still do.

THE OXFORD DICTIONARY defines an actor as 'a pleader, *b*) a doer, *c*) one who personates a character, or acts a part; a stage player, or dramatic performer'. That being said, and whether we like it or not, there's an actor in all of us. As Hobbes reminds us, 'A person is the same that an Actor is, both on the Stage and in common Conversation.'

The fact is that the instinct to pretend or dissemble is there from the kindergarten in all of us and it doesn't diminish as we grow up. We have only to attend a fancy dress party to see how a personality can completely change only because that person is hidden behind an outrageous hired costume or is wearing a mask. Even in real life, every adult has two faces. One might be called the Sunday face put on to impress or for special occasions, the other is normal weekday, workaday face. The latter may be considered the real face reflecting his inside self, the former is the front which is quickly put on if the situation requires the outside self. Two-facedness, it must be said, is not the total province of the actor. Such duplicity may be seen even more clearly in what grammarians call

the Phatic Exchange. That is, where words are passed in conversation, which are not meant to be taken seriously but provide a neutral buffer which gives both parties time to think of what they want to say next. Just think what you say when asked how you are when picking up the telephone. 'Fine' is the immediate response, no matter how you are. This is acting at its most rudimentary, as is all polite response.

Good manners may be considered as a whole tissue of little lies used out of consideration for others. There are many life situations when the truth dare not be told. All of us know when we have to pretend for one reason or another, to kid on. It is almost an emotional imperative, but we can't always manage it on cue. The actor can. That is the big difference. That, too, is always the thing that strikes one about actors – they are *different* somehow, of another caste, no matter how cast. It's not always definable but the difference is always there. It is as if they are of another tribe. Which is why one professional actor can nearly always spot another, no matter how crowded the room.

Basically, acting is a job like any other, but in the doing of it, actors can touch places, via the audience, only the artist can reach. It is an art, but the dramatic artist doesn't occupy an ivory tower, or, if he or she does, it has windows. There is a need in the work to look out to the world, for it's the passing world that is served, not the artist, even if the means to do the job comes out of the self, for the whole body is the actor's bag of tools. What is revealed by the use of it is the reflection of what is contained in any given script. In this way, the inner light is passed to the people in seats and enables them to see what he sees.

The interpreter role is often one which defines the actor, but the job is more than that, just as a great pianist's rendering of a concerto is more than a mere playing of the notes. Everyone, however unsophisticated in theatre-going or unlearned in the drama, knows at once the difference between bad acting and good acting, and between good acting and great acting. That's what the job's about – getting the best product to the customers, on time, and in good condition. And the real reward, in the end, is their satisfaction. Everyone appreciates applause, but the performing artist knows the value of silence as the highest applause possible. This is when an audience catches its collective breath and it is almost as if music sounds in the silence. It is the highest reward possible and, when it happens, it is unforgettable for both parties. Anyone seeing a play carries home

their own vision of theatre. People rarely forget a great performance because it is the ultimate in communication. It is person to person at the very moment of creation.

For this reason, the great classical plays can be performed again and again over the years, because the cast changes and we experience the work through different eyes. The play is still the thing but the medium of performance is changed because the actors are changed. In the conservative public eye, however, even in today's permissive society, the word 'actor' itself still has a faintly pejorative tinge. The very word 'theatrical' has a dubious ring, because people are subconsciously aware of the pretence implied. Despite the current cult of celebrity, with the worship of fame for its own sake, people tend not to trust the 'actor' in their midst, and will discount his extrovert behaviour as 'stagey' or even 'phoney', but these overt behaviourists are rarely professional actors. They are loud but limited people with personality defects. They might thrive for a time in their own limited circle but they would find it harder trying it behind a proscenium arch or on an apron stage. Nonetheless, the acting pro is still tarred somewhat with this sticky brush of suspicion. People are always curious about actors but it is always with the underlying feeling that they are not quite 'one of us'. Why does the public think it knows actors, when all they know is their work, and whatever few personal facts a programme shows or a publicity blurb reveals?

Yet the first fact is amazing enough. The actor is a flesh and blood creature who aspires to joy, in order to share it with an audience. In that simple aim is everything the actor is about, or should be. This enchanting consequence doesn't happen every time he sets foot on a stage but it happens often enough to make the performer go on striving for it nightly. That's as good a reason as any for trying to keep in work. Only in the work, or underlying it, can the real person of the actor be found as he goes about his business, which is as a stage alchemist attempting to turn words into gold.

It is this sort of chemistry that excites emotion. That's what the actor is for, to perform an action where the whole body is utilised towards a given effect. It's no accident that a whole career is rightly called a body of work, because that is both its source and its summation. Just as factory workers go to the assembly line to fit parts into the whole, the actors report to a theatre where something is made of the parts to make the

whole for them, which is the play. Out of the self the correct components are found. First, to the heart, where intuition lies, then into the mind, where decisions are made, which are then implemented via the gut where instinct lives through the solar plexus which is at the root of all emotions and the final result is transmitted to the limbs and voice – particularly the voice, the final organ of expression. Above all else is the voice. It is the principal theatrical tool. This is in no way to ally it to elocution or the pursuit of the voice beautiful. Rather, it is to serve as a prime marker, a signal of individuality. This identifies the player as a unique component in the theatrical exercise and it largely determines how an audience responds to the part played. To the audience, the actor is the word before all else. Let him look like a god or her like a goddess but let either squeak like a mouse or grate like a rusty hinge vocally and neither will be considered by paying patrons. Audiences will also quickly take in the length of nose or number of chins on the actor or the figure of the actress. All actors are aware of this close physical scrutiny hence their care to try for a good first impression. A bad one takes a lot of good acting to efface.

The first call made on the body is to ensure that the psychological stamina is there to deal with the expansive demands of an impossible profession. In what other job does one have to pretend to be somebody else in front of people who are well aware of being deceived? In what other job is the hired hand regularly sacked at the end of the month or the week, even the day? And some jobs hardly go beyond the hour. These unusual work habits require an adaptable physical and mental response and this is what asks most of the actor. Standing for an hour on a raked stage wearing a sweaty costume, with a spear in one hand and a shield in the other can be tiring. Moving through a long play is to walk the mile or more, speaking at all is an effort at times, but speaking to a full theatre so as to be heard, can be exhausting. Not to mention the concentration involved in keeping the words on the tip of one's tongue. So yes, being an actor takes its toll.

It is small wonder then that actors are so preoccupied with self. They are their own life-machines and they owe it to themselves, and their audiences, to keep it in good running condition. They can almost be for-given this 'ME' obsession when it is seen how they have to rely on it. Some actors of course carry this into their off-stage lives. The story is well-known of the actor who so dominated the dinner-table with an interminable

conveyer-belt of self-based anecdote, albeit amusing, that even he was aware he was outstaying the listening stamina of his fellow-guests.

'I'm so sorry,' he said unblushingly. 'I've talked enough about myself.' Then gazing round the table he said with a beam, 'What do *you* think of me?'

There is no record of the response.

What is certain is that not all actors take their egos to dinner parties. They know the risk of having to eat their own words.

All actors ever want is to do the best they can with the text provided by the dramatist, the clothes supplied by the wardrobe department or the props begged or borrowed by stage management, but of all of these, the words on the page are the primary tools of the trade. Add a little application to study, some imagination in seeing the possibilities, a lot of concentration at rehearsal and given a bit of luck on the night, the actor can fuse these elements in what amounts to a mask, a disguise that will screen all his working parts. When he has honed this process by repetition into rehearsal and arrives at a living, breathing character, only then, having run it past a director, of course, can he confidently present it to a paying 'house'. The audience is the final arbiter, the 'bums on seats'. Which is why paying patrons were called 'seats' by old actors, although old actors weren't necessarily called 'bums' by patrons.

The most persistent question asked by 'seats' is, 'How do you learn your lines?' 'With difficulty,' is the immediate retort, but there is a genuine effort made by the cold sweat of sheer 'swot' in the privacy of the bedroom or study. Lines can be learned anywhere, on the top of a bus, in the underground, while driving (but that's not recommended) or even sitting on the lavatory. This reliance on memory is the very kernel of the actor's trade. They may have raging talent, every aptitude for this special calling and looks that charm and disarm but if they haven't got memory, all these gifts are as naught. An amnesiac actor is not a good job risk.

The prime intention in his profession is to be the medium of the drama, which is literature written specifically for the stage. This demands an acute awareness of quality in the written line prepared for speech, which is why good drama is not always good literature. In addition to this sensitivity to the text, the actor requires a level of intelligence, technical skill and emotional acuity, not to mention a stamina that would credit

a sports-loving university don with artistic pretensions. It is a big ask of four limbs, a decent mind and a big heart. Creativity is a tough taskmaster and demands all from its servants. This underscores the importance once again of the interpretative role given the actor. How would a Bach partita sound played by your average pub pianist ?

This can be understood when one considers the difference between reading a play and witnessing its being performed. Plays are made to be spoken, not read. The former is like seeing a photograph, the latter is a flesh-and-blood study in motion. Naturally, actors don't do this all at once, but slowly over the course of the rehearsal period. They gradually work out the graph of emotional peaks and troughs and work through their sequence. They have to know when to conserve energy as much when to give their all, but yet they never quite give all of the all. They always hold something back. They have to or they might lose control, the essential *self* control that is at the root of all good acting. Like any good driver, something is always kept in the tank for emergencies.

The word-learning secret is that the script is put into the brain by relating to the on-stage, rehearsal moves given by the director. One speech begins at the door and carries the actor to the table. Another as a sit is called for and another as a rise is written in followed by a move to the window. Yet another as a turn is suggested to deliver the next speech facing downstage and the last speech is given on the move up to the door again. Each move triggers the line and each line indicates the move. It is remembering by association. Working together this way, a whole act can be put into your head in a week and the whole play in three. It's a totally cerebral process in order to gain an emotional result. This is why actors are usually good at crosswords, they have a brain for words. In addition, the cues given by the other actors link the mis-en-scène and provide an additional hint to the appropriate reply.

Gradually, the whole fabric of play is built up much in the manner of a spider's web, the spider being the director and the different strands the actors involved. The whole play, or at least his part in it, goes into the head like a tune to be remembered and the words can be 'seen' like notes in a score, and can then be 'sung' in the head as the motions are gone through. 'Know thyself' is the famous dictum, but 'Know your words' is more vital to the actor. As Noel Coward advised the young actor, 'Just learn the words and don't bump into the furniture'.

In the beginning was the word, perhaps, but, in the end, that's all that matters. If the actor's first duty is to satisfy an audience, the second is to serve the playwright's intentions. The writer is the architectural (or is it architextual?) wellspring of the theatrical ground plan. The actor's job is to see that the building is completed to the smallest specification on the night.

'What do you do during the day?'

That's the second most-asked question of the actor. People assume actors must have a day job as 'acting isn't a real full-time thing, is it?' At best, they think it a temporary phase that one grows out of like playing video games or collecting football programmes. The consensus is that it's not a 'proper' occupation. It isn't in many ways but why do so many otherwise kindly people think all actors and actresses odd, ambiguous in their sexual orientation, and, like jockeys, airline pilots and freelance writers, dubious insurance risks? Now we all know that nobody is totally sane, everyone suffers from something or other, however trivial, and all have known illness at some time in their lives, and no mother ever thought her son ugly, yet why are actors not held to be a part of this huge swathe of mankind, but somehow apart from it? They are considered at the least, according to the average man in the street (if there is such a thing) to be atypical, if not downright abnormal. But what is normal? Actors are people, and therefore as normal as anybody else, but they could not act effectively without arms and legs, eyes and ears, a good memory and a bit of a brain. Nor could they easily maintain a professional career when disabled, although many actors have overcome such difficulties, and have done so courageously, but it is generally accepted that for the average actor, the required working apparatus is a fully-functioning, 'normal' anatomy. The point to remember is that while the unholy trade, as theatre is sometimes called, may be abnormal and strange in many ways, the ordinary player is not.

Why then do so many want to go on the stage? What is the lure? It is not just the applause, although that is very nice, or the money, which can be rewarding. Or fame, or travel or getting to meet interesting people, which appears to be the ambition of every beauty contestant. What draws the actor is the on-going contact with the audience throughout the performance, and the absolute bliss of their growing involvement as the night goes on. That's the real payback, and it makes all actors as high at

the end of the night as they might have been low at the start. This is a drug more powerful than any available, and it's just as habit-forming. Once the actor has tasted that peak of applause, which is that shared silence already mentioned, he finds it difficult to settle for less. It is not, however, something that goes with contract, it's a consummation devoutly wished by every actor, a final blessing given by the audience. That's what makes the work worth it, and justifies the risk actors take, of voluntarily putting down the plank and walking it.

The first thing the public has to understand is that acting for a living is not a job, it's a vocation. It is done because each actor wants to and if they want it enough, they usually do it well. Once the vocation registers, in whatever aesthetic field, all artists have the feeling of not having to work another day in their lives. For those in the theatre, it's all play, so to speak. It is true, though, that to do anything well you need to have the heart for it. Get to the heart of the matter we are told. The heart's the start. All of life emanates from this simple process of breathing in and out so what is more basic? The heart rate varies and no one knows that better than the actor.

Hearts start leaping at the sound of the telephone and race when it's good news. Good news about getting a part almost always comes by phone or voice mail, the bad, if it comes at all, is mostly by e-mail or letter, but usually, no news is bad news. By the time the actor is standing in the wings in the theatre waiting to go on, the heart is back in the mouth where it always takes up residence at openings and the main worry is whether a word will get out past it when the first cue comes up. The brain tries its best to reassure the body by remembering that all this has happened before and calm is called for but actors listen more to the heart than the head. At times of great emotion this organ is always a better indicator than the brain, and waiting to go on in a play is emotional. There's electricity in the air but the heart has its own energy charge and it makes its impulse felt. Even if legs are weak, hands are shaking, and heads are spinning, the blood is up and the heart is strong.

This gives the actor his final attribute – an accepting fatalism. What will be, will be. Waiting behind the curtain on the opening night, the chance is taken to look through the peep-hole in the cloth. It is there to allow stage management, in the days before the inter-com, to decide whether everyone was seated and that the curtain could go up. It was

also for the actor-managers to look out and 'number the house'. To do this they quickly counted the empty seats and deducted it from the known capacity. In this way, they would have a precise idea of what their due percentage was when they were paid by the theatre management at the first interval. Actor-managers never trusted anyone, least of all, other managers.

Actors, on the other hand, trust everybody; their agents, their colleagues, and most of all, themselves. They learn as they go on and continue to survive 'on the boards', that they have responsibilities, the first of which is to do their best work for its own sake, for the pleasure of others, for rightful gain but also to justify whatever talents God has given them. Trusting in these gifts, no matter their extent, actors confidently, and often innocently, face up stoically to the hazards ahead. No matter what happens, they need to keep the fire in the belly well stoked, or at least ensure that the flame is still alight.

Getting Started

HISTORICAL ASIDE

By the 10th century the profane drama of the market place becomes the religious theatre of the liturgy as the early Catholic Church incorporates impersonation and enactment into its rites. The actor comes off the road and learns Latin, then strolls up the aisles to perform in playlets as part of the Mass. The people demand a greater involvement and the actors respond with the Mystery Plays sponsored by the Craftsmen's Guilds. The Bible is plundered for plots and the drama in the vernacular is reborn in the streets. Heaven and Hell are created as stage sets and scripts are written which give the Devil all the best lines. By the 12th century the Creation of the World to the Last Judgement is dealt with in days by teams of local actors on the cobblestones of York, Wakefield, Coventry and Chester and the Church goes back to being a Sunday observance. The drama is back where it belongs – with the people.

'Hi diddle-de-dee, an actor's life for me,'

WALTER CATLETT'S SONG MAY have said much for the puppet Pinocchio, in Walt Disney's charming 1940s film, but it adds little to the sense of the actor's true development as an interpreter of the human condition in an amenable environment. The truth is that the average actor's professional life today hardly begins with a high silk hat and a silver cane as Mr Catlett's lyric further tells, and a watch of gold is out of the question, with or without a diamond chain. The first speaking part is the starting point. All roads lead from here. The actor has only begun on the trek that might take a lifetime. The following is a list of just some of the items of luggage that might be required on the theatrical journey,

Courage

as much as talent, is almost the first quality needed by all young performers. Raw courage, both moral and physical, is a must for them, for it is a brave

thing to chase the long odds against ever making a living, never mind a success. 'Going on the stage' as it is called is always a dare, but the actor, starting out, never doubts that he or she is going to make it. Theirs is an allowable bravado rather than a considered bravery but it is born out of innocence rather than ego and will soon be tamed and re-tuned if progress is made. Nonetheless, it is no mean thing to take the leap in the dark that entering into a stage profession is, but it is certainly worth braving the rapids of opportunity and surviving the whirlpools of emotion that each day in this rocky profession offers.

Imagination

to lift the spirit above the prosaic business of finding a job in the first place and making a go of it when offered, is a bonus for all beginners in the Art of the Drama. The correct mental attitude is the parachute that keeps the young performer above the crowd in any first attempt at career 'lift off'. Discouragement may come from all sides at the start, and more often than not from within families, but if the will is there the flesh will respond. Once started, there's no saying where the path will lead. The very uncertainty is part of the excitement and it is this excitement that provides the wind currents to blow the hopeful parachute on its way to a safe landing on the lower stage slopes.

Confidence

in a trained ability is a sturdy assist in the early years. Added to this is a trust in the profession's early appreciation of this indicated by gradually increasing offers of work. It's amazing how soon word gets around in the theatre of an emerging talent. The grapevine is always ready to welcome a new strain. Agents and producers are constantly on the look-out if only because their own livings depend on catching the best of the new crop each year. The pitfall is that over confidence is just as much a deterrent to possible employers and has to be guarded against.

Optimism

If imagination is the parachute, optimism is the lifebelt when rough seas are encountered in the early years. Hope is the easiest thing to lose but a most valuable faculty to retain. An optimistic patience has to be developed along with an endless stamina to keep afloat somehow and this is where

the lifebelt is useful. What is just around the corner must be kept in mind, if not in view, and should be worked towards doggedly. Persistence is a good ally and brings its reward in due course because the artist-actor knows that what is meant for him or her will not elude them. Even so, fate must always be given a helping hand.

Enthusiasm

is perhaps the greatest gift of all and one to be tended and treasured throughout a whole career. Under its other name, Love, it embraces almost everything the actor touches. There is, foremost, the over-riding love of the work in all its aspects, of colleagues and friends in the theatre, of relationships that bloom quickly in the hothouse of rehearsal. These may last a lifetime or a single night but they are important signposts on the way to maturity both as an artist and a human being and none must be discounted. Enthusiasm for anything is an angel-gift, even for 'luvvies', but the ability to keep it fresh and viable throughout a long stage career is a God-send.

There is undoubtedly some vestige of folk memory that has gone down through the years, that actors are still undesirables and that on no account would any respectable father let his daughter marry one. Some must do, however, and as a result, the strain perseveres, as they say in the horse racing world. Where, I may say, the gamble on success may be much less. Actresses, for their part, did begin in theatre as no more than prostitutes, despite the 'Mrs' attached to every female name, but things were very different for all theatre practitioners in good King Charles's golden days. Although the first actresses began by selling oranges to theatregoers, Eve gave her apple for free, thus showing that woman was the first to take the initiative. This was certainly true of the later actresses whose abilities kept pace with their rapidly improving moral stance and they were more than a match for the powerful actor-managers of their day.

The modern actress has taken this even further and, what is more pertinent, taken it for granted that she should do so, so that now she is completely on a par with her male equivalent. And often his superior. Women in the theatre abound, not only as actresses, but as directors, designers, dramatists and dramaturges and there are even those who risk their own hard-earned money as producers. Complete parity has been achieved and Equity is now synonymous with Equality. We are all actors now.

Yet, whatever the gender, every actor has to start somewhere. Most begin after some kind of training for the theatre whether it's at the august Royal Academy of Dramatic Art in London or at any one of the now well-established acting schools in all the main centres, and if you are precocious, there is Italia Conti. There may still be little old ladies on a fixed income who teach elocution from the slightly dog-eared family mansions in the better part of most towns in Britain, but these are a vanishing species. Nevertheless, the roads leading to the West End are many and varied. School drama clubs, or a choice remark by a teacher at school, the amateur drama club, a chance meeting in a pub or club, a course of speech therapy, any or all of these might be the path that leads to the lane that leads to the side road that leads to the motorways of fame and fortune. And, of course, there is the always the ubiquitous amateur drama festival.

People say it's all a matter of luck, whatever one does in life, but luck doesn't favour the trepid. You get to grow old in the theatre by being bold. Playing safe only blunts the edge of ambition and it is impossible to cut through the barriers put up before the primary objective which, in the actor's case, is to land a part however small, and to win the right to play it on a stage, and be paid for it. That first speaking part is the passport for the long voyage ahead. This is when the tyros draw on all the 'luggage' qualities mentioned above as they wet their feet in the shallows of their future profession. Statistics tell us that half of all professional actors are out of work at any one time. This is a damning percentage by any standards, yet every actor begins with the certainty that he or she belongs to the working half.

To do so, they will do anything, go anywhere, with a daring and ruthlessness of aim that would be hard to sustain if they were training as chartered accountants or solicitors or, as so many actors have been at one time, doctors. The stage vocation calls for the same dedication as these callings but also depends on a certain reckless foolhardiness based on a quite illogical optimism that all be well eventually. He may be knocked down from time to time, but he will never be knocked out. These high hopes are maintained by physically surviving as a barman or waitress, becoming a part-time carer, or featuring, between acting jobs, as an 'acting patient' in a medical teaching hospital.

Our sympathies should go out to any well-trained, talented professional

who has to eke out a living in this threadbare manner while waiting for that telephone call that will change everything. 'Temping in Sidcup' becomes the only option as one excellent actor put it when parts were few for him for a spell. There have always been more actors than parts available, and many don't survive this early, trying stage. Where they might have been contenders they become resigned pretenders. Many, however, go on to make splendid teachers of drama, so nothing is wasted.

Good actors always get by somehow but what is astonishing is that there are so few really bad actors in proportion to the numbers of actors extant. Audiences have a way of weeding out the non-triers and word soon gets around the casting offices – indifferent actors generally do not advance, but there are exceptions. Ham actors do exist. It is a species that strives for the big effect from little means. The name came from the fact that the pig in question carried too much fat and had to be cured. The acting ham, however, remains stubbornly uncured throughout an uninspiring career and is usually quite unaware of any personal deficiencies, blithely blundering his way through performance after performance. How such actors remain in employment is a mystery but you can be sure that the ham is never aware of the egg on his face. Embarrassment is a sensation totally foreign to this type. Of course there is always a chance of any actor's being miscast from time to time but to be consistently ineffective in every part played requires talent of a kind.

Failure, alas, can be contagious, so actors tend to stay away from the determinedly unsuccessful if they can. Besides, there's always something that can be done while waiting for that next acting job. Some actors become very adept at 'Do-it-Yourself' jobs around the home. They regard it as working on their investment. The home has been bought with the proceeds of a good spell and it is in everyone's interest to keep it up to scratch, so out comes the hammer, the screwdriver or the paintbrush and a good day's work is put in.

One well-established actor had a long run in the West End with a good part in a good play. This was rewarding in both senses and it got him a useful film role. He spent a year in Italy going from one imbecilic film epic to another. He came back home and it was said he carpeted his double garage with the proceeds. What he did do was build up his four-acre property substantially, and, until the end of his life, when out of work, he would sit on his motor mower cutting each of his four lawns

at his property in Berkshire. 'Cultivating his collateral' he called it. He could wait happily for the next part to come up and knew too, that it didn't really matter if it didn't.

Not all actors are as fortunate. Last week's Romeo might be answering phones at so much per hour this week, and his Juliet might be working at her local supermarket. You can be sure that they will play these parts as well as they did their stage roles. The actor is nothing if not adaptable and the best ones are always cheerful. They know that everything goes round and will come round again. The telephone could ring at any time and it could mean Birmingham, Warwickshire or Birmingham, Alabama – which is why the passport is always at the ready. The excitement of the unknown is still the best antidote to the growing panic of the waiting time.

The-actor-in-waiting adjusts to existing as opposed to living, knowing that if the call for that audition or interview doesn't come today, it will come tomorrow or the next day – but it will come. It must. Until then, the best face is put on things. The prism is turned so that it picks out a stoic expression on that face that will serve until normality resumes. Some of the best acting is done when out of work. There is a kind of rhythm to this upside-down, inside-out manner of earning a living but it's only evident in retrospect. At the time, it's hard to get through with a smile. Imagine how the plumber would feel if, after every job, he was laid off, and then before starting another, he had to give a nifty demonstration of changing a washer. Or the joiner was asked to knock up a quick bookshelf while we watched, or take his plane to the edge of an ill-fitting door before being taken on by a critical client?

Yet every time the actor goes looking for work this is the procedure gone through. In effect, with every audition, the actor is, in effect, starting all over again. And this happens, one way or another, all through a career, no matter how prestigious. Which is why there is such stress on the need for optimism and absolute certainty of vocation. These are bulwarks required against the occasional rejection. So often it comes from individuals for whom the actor has little respect, but who have absolute power at that moment to determine the actor's immediate future and if the part is significant his whole life. Yes, the job interview is a crucial hurdle.

However, as time passes and enough of a marketing name is made to be known to the agents or managers, invitations arrive to have a drink,

or go out for lunch or even a formal dinner to discuss a possible part. This is one way the agent or producer makes sure of eating well, but the actor on trial hardly has the same appetite. He has little comfort in knowing that very few in the business are exempt from this testing prelude to employment, however polite or luxurious the circumstances. There is a story in the theatre of how a very distinguished theatrical dame, a genuine star, and mainstay of post-Second World War theatre in Britain, was asked to meet with one of the young, university wunderkind directors to discuss a new play in which she might feature. The young man was not all over-awed at meeting one of the theatre greats, and when they had settled in their respective armchairs at a well-known London hotel, the young man asked the redoubtable lady,

'Tell me, Dame Edith. What have you done?'

The grand dame regarded him haughtily, then said in a voice of ice with that famous rising inflection, 'You mean today?'

Some actors, however talented on stage and respected for it, have no audition or interview skills and rely on their work to speak for them. These actors have a genuine modesty, even shyness, which they lose in their work but which reasserts itself in the one-to-one-situation of the job interview. Even worse, in the cattle-market atmosphere of what is called the mass audition for the larger-scale production, many actors prefer to forfeit the opportunity rather than go through this shaming protocol. It must be understood that the actor is in a very frail position at such a vulnerable time.

Is there a life outside acting for the actor? If there is, actors hardly notice. They must continually live on the razor edge, dividing their private and professional selves, aware that the slightest slip on their part would cause harm or disappointment in either or both segments. Over-concern about theatre risks losing much of their personal life. If too much attention is given to off-stage matters, then momentum can be lost in the inward drive that pushes their careers forward. It is a tricky balance to maintain, and mistakes are made. Often being out of work requires more stamina and energy than the most arduous role on stage. Actors are so buoyed by the sheer exhilaration of performing that they live off the adrenaline for much of the time. Stamina is needed to keep up a good level of work but even more is needed when there is no work.

The irony is that being unemployed in the theatre is called 'resting'. That is the last thing it is.

Resting for the actor means sleepless nights, long, empty days, being tied to the telephone, losing the appetite for food but gaining a compensating thirst. It is easy to become heavy-handed with the bottle and the family pretends not to notice. Tempers become brittle as the feeling of failure makes itself felt. Lack of self-esteem quickly follows because being out of work is to feel unwanted and inadequate and this is depressing and debilitating and drags at the actor all day. Obvious self-pity now takes over and this doesn't improve the chance of understanding in others, still less sympathy. Reassurance is sought from any quarter and when it is not forthcoming there is a tendency to take an obsessive interest in anything that doesn't remind you of performance. Anything to forget.

Actors have tried to become painters in their 'rest periods' or tried to write that great novel, but most remain numbly idle. Time hangs round the neck like a stone. The greater the attempt to keep busy, the longer the day lasts and life itself begins to seem trivial. The sitting-room couch has been sat on so long it needs re-upholstering The out-of work performer is a pain in the arse to everybody, but only a wife, or husband or partner, will actually say so. If they have families, the children keep out of the way. This is a shame because a young child can give the pre-occupied player a sense of proportion, a truer perspective. Children don't understand any adult who sits staring at the telephone for much of the day.

Then one day, it rings.

It is picked up before the first ring has finished and you can be sure it would just be the same whether that shrill sound echoed in a suburban room, luxury penthouse or country cottage as the unknown out-of-work actor or the unknown out-of-work actress grabs for their common life line. The conversation is always the same.

Agent: 'Hi. How are you?'
Actor: 'Well?'
Agent: 'Good. Well. something's come up.' Actor's heart jumps.
Agent goes on.
'It's not the lead but it's a good part, wardrobe will call sometime next week, they'll call you, rehearsals start the following Monday. Usual feature billing just under the title, money's okay and you die at the end

of the second act, time to get out to the pub or home early if they let you miss the curtain.'

The agent goes on about other technical details but the actor is hardly listening. The he-actor is already paying back a few debts he has built up, the she-actor thinks she might get that coat after all. He can't wait to tell his wife, she can't wait to ring her best friend. They both kiss the receiver as they put it down and give out with a loud 'YES'. A hug is given to the first person they meet, whoever it is, and they have to listen while the actor tells them about the play, and his or her part in it. It's all exuberance, hysteria and fun and will last most of the day. Some actors go at once to the pub and others go and drink in the garden. The air has never smelt so sweet. The waiting is over. How long has it been – three weeks? Three weeks? Was that all? It felt like three years.

Barren spells start for all sorts of reasons. Changing agents is a common cause. Agents retire or move to California and the actor has to look for new representation. Actors can't get anywhere without an agent. The species is a godsend on good days and a bloodthirsty leech on the bad ones, but good agents know how to deal with their client who wavers at all times between his actor's ego and his artistic self-doubt. Fortunately, the right actor always seems to find the right agent by trial and error and a kind of marriage is embarked upon, for better or worse till the Inland Revenue doth them part.

To the agent, for the most part, the actor is little more than a commodity, something to be traded at the best price available, with very little thought given to aesthetic matters and none at all to any personal needs. The price was all and the time involved the second important factor. This very objectivity is what makes a successful agent. He or she must remain at a remove from the client, otherwise both go through the emotional roller-coaster the actor's life is. Some agents don't go to the theatre. They are content to act as bookers and wait for the mountain to come to Mohammed. Being Jewish, as many agents are, is no debarment here. They handle the telephone as if it were a Stradivarius and play it on behalf of their actor-clients to their mutual advantage. If the agent keeps working so does the actor.

Actors never forget any extended spell of out-of-workness because, at the time, they never know how long it will last. It could be a matter of weeks or months, it was hard to tell. Which is why savings are dipped

into, overdrafts are looked at and everyone wishes they had an ancient wealthy relative who is imminently dying. It is impossible to budget or plan ahead and all actors feel ashamed of putting their nearest and dearest under such a strain. When actors are out of work they are sure their careers are finished. There is even the horrible thought at the nadir that they'll have to get a proper job.

Of course, being rational, they realise that this is not only unintelligent, but unlikely. However, in the state they are in at the time, they are neither rational nor intelligent. Their only comfort is in knowing that a long period of rest is unhealthy and things will get better soon. Something always comes out of nothing. It always has before. 'Hope springs eternal' but never more so than in the undaunted, but palpitating heart of the out-of-work actor.

Even finding a job again has its unexpected shocks. One actor couldn't wait to tell his best mate, another actor, that he'd got this lovely part.

'Oh,' said his friend softly at the other end of the phone.

'Is that all you've got to say then?' said the actor. 'What's the matter?'

'I was up for the same part.'

'Oh,' said the actor. 'Sorry, mate,' he whispered.

And with a wry grimace, he put the receiver down very gently.

The Director's Team

HISTORICAL ASIDE

1576: The Theatre is opened by James Burbage at Bishopsgate in London, the first specifically built to house plays. Shakespeare joins the Chamberlain's Men, led by Burbage's son, Richard, and featuring Will Kemp as Clown. The Admiral's Men play at the Rose Theatre in plays by young Christopher Marlowe featuring Edward Alleyn, the first name actor since the Roman Roscius, supported by another great clown, Richard Tarleton. 1594: Shakespeare writes his first play 'Love's Labours Lost' and in 1611, his last, 'The Tempest'. The period between these two plays represents one of the richest theatrical eras in dramaturgy. It marks the beginning of sophisticated, philosophical acting provided by the great tragic parts like Hamlet, Macbeth and Lear. The actor comes off the road, steps down from the altar, enters on to the new stage and begins to act in the gallant, knightly style of the age.

THE 'THEATRE OF DREAMS' IS the name now given to Old Trafford, in Manchester, the home of the most charismatic football team in the world, Manchester United. Here, 11 young men in red jerseys perform every other Saturday afternoon, and often mid-week too, in their state-of-the-art, all-seated stadium as a regular football drama unfolds before an audience of 76,000 rapt spectators. It's a big 'house' by any standards. But then every game is a big occasion for them, and their big games are national events. To many who know nothing about football, there is every chance that they will have heard of Manchester United, and if so, they'll know its football 'director', Alex Ferguson.

Sir Alexander Ferguson is a cherry-faced Glaswegian with a fondness for Robert Burns and chewing gum, and also for taking Manchester United to every success available in football since joining them in 1986. He has won everything that can be won as a manager, building on his success with Aberdeen in Scotland, where he had learned his managerial

trade, first with East Stirlingshire and then with St Mirran. He is acknowl-edged as perhaps the greatest football manager of modern times yet he was no more than a modest player with Dunfermline and Glasgow Rangers. This is where he is similar to so many great theatre directors. Neither species of boss has been with us long in the overall histories of these two types of play. Football players used to play in packs of 20 or more with every man for himself in a mixture of running, kicking and carrying of the ball out of the general melee. The manager arrived with the 20th century as clubs became more like businesses and some order and unification was called for. The first clubs formed an association, and so Association Football was born. This sort of association, on the other hand, never happened in theatre until the companies of players evolved in the Elizabethan renaissance.

It is almost a truism that in the theatre the very best directors were never great actors. However much they may have been drawn to the stage as performers in their youth, they soon found that their forte was not in doing it, but in helping others to do it better. There is a great skill in this, not least, the gift of tact and people-management. There is as great a homogeneity among directors as there is among actors. There is every type in the trade. These categories don't change much even if the names of the directors do, and they come under five main headings:

The Scholar

who is engrossed in the text while the actors run wild leaving the tech-nical issues to the Stage Manager, who barks loudly but has no bite.

The Bully

who comes to rehearsal in jack boots and behaves accordingly. He is less concerned with text than with making parade ground spectacles.

The Diplomat

who hardly raises his voice but coaxes a performance out of the kind of actor who doesn't want to think for himself.

The Architect

who uses the actors as bricks and mortar in the building plan he has worked out at home and squeezes them into his shape whether they like it or not.

The Bricklayer

who is on site with the workers from the breaking of the sod at the read-through until the topping off on the first night. The edifice of the production arises gradually under his hand in tandem with the actors and its shape is never completely realised until it is presented before an audience. This is the kind of director actors prefer.

Actual names are invidious in this respect. The ones that loomed large in one generation are replaced by the big names of another and so on until we reach the titans of today, some of whom might already have faded by the time this book is in your hand. That is the very nature of fashion, it comes and it goes, and volatile theatre is as much prey to passing trends as haute couture, but whatever hat the director chooses to wear, the actor responds to him today in much the same way as when the species first came to be recognised.

The theatre director, as such, wasn't known until the coming of the railway network in the early 19th century and the impact this had on touring companies coming out from London. The leading players of the time used to take rehearsals themselves and this mainly took the form of 'Sir' standing centre stage with both arms outstretched and telling everybody to keep their distance and stay out of his light. When they got to the dress rehearsal stage, the leading actor would send his man down into the stalls with orders to shout out if anyone in the company 'masked' him, meaning that they stood in front of him and hid him from audience view. The man in the stall then became known as the 'director' as he would direct 'Sir' where to stand in order to be plainly seen from all parts of the house.

The leading Victorian and Edwardian actors took tours of their current productions 'on the road' which meant out from London to the provincial centres, either before opening in order to try out new works, or after the West End run in order to make a few extra guineas. Rather than send his man to the stalls, the actor-managers would send him around the country. He went ahead to every theatre on the touring schedule and would meet with the local actors in each area who would then be hired for the lesser roles. They would be given their 'sides' or appropriate 'parts', which were printed copies of the smaller roles not being played by the London actors. 'Side' players rarely knew what the play was about. They were there only to do their 'bit', for which they were duly rehearsed by the manager's man much in the manner of his employer, standing

centre-stage and directing the stage traffic. On the arrival of 'Sir' and the touring company he would move on to the next town to do the same all over again with that town's local players.

It was not at all sophisticated but it was practical and it worked. The actor-managers benefited from not having to tour a full cast from London, which was expensive, and the local actors enjoyed the experience of working with the big names. In time, these provincial players would themselves become actor managers and the process would continue with their representative being sent ahead. Over the years, the director began to take a greater part in the rehearsal practice by offering suggestions and/or recommending moves. From the stalls, he got a more objective view of the ensemble and these comments from the stalls became increasingly effective. So much so that the star actor ceased to direct from the stage and left it more and more to his man below. Not that he gave up his final veto. The old actors always had a good sense of how things looked from the stalls or the circle.

Thus, from this humble, subservient chore, the practice of 'direction' grew until it became the lofty, omnipotent office it is held to be today. So that we hear, historically, of Rheinhardt's *Everyman*, Komisarjevsky's *Macbeth*, Guthrie's modern dress *Hamlet*, Brook's *Lear* and so forth. Peter Brook, arguably, the greatest theatre director in the world today, is still at work from his base in the Bouffes du Nord in Paris, where he has established his International Centre for Theatre Research. At the time of writing, he is producing '*11 and 12*' about Tierno Bokar, a Sufi Master who taught Islamic tolerance. This was inspired by a book written in French by African writer, Amadou Hampate Ba. Like Bill Bryden, a Scottish director whom Brook admires, Brook enjoys investigating large themes, employing large casts in non-theatrical venues. Yet he says his approach to theatre is best summed up in the impact made by the last line of a play he read at university. 'There's a man alone on the stage,' he remembers, 'and he just says, 'I don't understand the world any more.'

It is vital in any production that the Director make his meaning clear. This tells the actor that he is in the hands of a someone who knows what he's doing right from the beginning and not like the poor actor who was bemused to find himself being joined by another actor in reading the lines of a particular part at the first run-through of a new play. 'Sorry darling, you're reading the wrong part,' purred the director languidly.

'But you cast me in this part,' replied the actor.

'I know, darling, but I changed my mind.'

'Well, you didn't tell me that,' retorted the actor, understandably annoyed.

'Didn't I, darling? So sorry. You're reading Happy. Shall we continue?'

The actor was not at all happy and showed it but he had to read Happy as directed and with as much dignity as he could. He knew the score, he was a pro. Better a lesser part than no part at all, but throughout the consequent run he was not a 'Happy Chappie'.

A rising element in the field of contemporary direction is the emergence of women in the position. No doubt, the female directorial names of the modern era will be enshrined by future students of the productions they master-minded, but it is as much of a fact that the ordinary theatre-goer will continue to remember what they have seen in terms of the actor rather than the director or designer. Didn't one American critic say that the audiences don't come out whistling the scenery? Theatre is still at heart, a flesh-and-blood experience, and no matter the cerebral input by clever and talented people gathered backstage to put the actor in front of the audience it is still the person of the actor that draws the audience. The performer is still foremost, the outward face encompassing all the industry and effort put in by so many backstage.

The first real, practical lesson the actor learns when he has been on the stage long enough is to listen to the little bird which sits on every actor's shoulder or the angel at their ear, whichever analogy is preferred. This is the instinct that allows the actor to see the picture he is making on the stage at any given time. The idea is the little bird flies up and watches from the auditorium or the angel flutters on the proscenium arch and if you are making a poor picture, either in grouping or individual posture, they fly back to the shoulder or have a warning word in the ear.

Every artist, in whatever medium, has this kind of early warning system. Whether bird or angel, they are merely symbols of a heightened objectivity, which prevents the actors from ever detracting from impact by 'losing themselves', either physically or mentally, while on stage. It is difficult to have this outside eye if the performer becomes over-involved in his own mental attitude towards the part or too intricate in presentation, or 'up yourself' as the greenroom phrase has it. This is when actors fall in love with their own on-stage creations, but a dig in the ribs in passing,

or a whispered 'get you' from a colleague can avert this kind of indulgent impersonation. If not, a meaningful tap on the shoulder can save the day.

Harley Granville Barker must also be mentioned by name because he was that *rara avis,* actor, director, author, scholar playwright and theatre manager. Between 1904, when he joined J.E. Vedrenne to produce the plays of the young Bernard Shaw, and 1946, when he died in Paris while writing a Preface to *Macbeth,* he gave the theatre of this time an intellectual shot in the arm which inoculated it against the tea-cup dramas and pompous epics which were its staples. He was to theatre what Chaplin was to film and what Orson Welles was to everything. His was a large talent encompassing a huge field and the young, intellectual directors of today owe more to Granville Barker's example than to Stanislavsky's. The Russian was essentially an amateur, who genuinely loved theatre, but the Englishman was a thoroughly prepared professional who was aware of dramaturgy as a theory of stage practice, and that it boasted a literature deserving of study as much as the needs of the practical drama demanded detailed attention. His direction of actors, therefore, had a sound rigour based on his knowledge not only of the text at hand but also of its provenance and place in the theatrical canon. Granville Barker was the Admirable Crichton of directors.

In earlier times, the producer and the director were the same thing in the person of the actor-manager. He later divided to become the producer, who was the one who hired the actors, then 'produced' the play by directing their talents on stage in rehearsal. He also fired them. The producer dealt with all the administrative questions arising in the show, deducting income tax as necessary, paying royalties and talking to the press or to investors. He may not have been a Granville Barker, but the average 20th century producer was no mean slouch and, assisted usually by a middle-aged matron who always wore a hat and could type, he ran a tight ship. Theatres even made a profit in those days and the Arts Council or the local council was rarely badgered for funds. Gradually, the producer retired to his office and his ledger and the director became his own person and theatre was never the same again. The effective commando unit became an often cumbersome regiment.

The conventional director nowadays has to rely on his team. That is the backstage brigade, ready and waiting to carry out orders or come up

with better ideas of their own. First of all, presuming he or she is extant, the dramatist is the first consulted. Next is the designer, who will have a couple of painting assistants, and even a set dresser if it's a period piece. If there is music, we may have a composer, and that means a rehearsal pianist. That makes seven so far, plus the usual stage management, stage director, stage manager, and two assistant-stage managers, one to be prompter and the other as 'gofer'. You could include the company secretary, production secretary, publicist (with his or her assistant) and if you are really serious, you can add a dramaturg plus a couple of students from the local drama school who are there to learn and to feed the parking meters. Finally, you add the fireman, the stage doorkeeper, the cleaners, and the Front of House staff and sundry admin, and you have a whole array of production assists.

This is why modern theatre is so body intensive. Like everything else today, commercial theatre is a matter of practical economics but modern companies are increasingly top-heavy in non-acting staff. Why is it when cuts have to be made they always start with the actors? Suddenly, every play is a two-hander or a threesome at most – even better a solo. Drama today suffers from severe under-population on stage. Why not apply the same stringency backstage? Does every working theatre really need an assistant PRO or a dramaturg? Even the senior actors might be better employed in this capacity. After all they have an experienced and practical view to offer.

Not enough use is made in today's theatre of what has been learned by actors on the long road up from holding a spear to holding the leading lady. A good performance and the word of mouth it elicits is the kind of publicity no money can buy and has been the basis of theatre from its beginnings. Senior actors know that the audience always knows first, and knows best, what is good in theatre, what works and what doesn't, whoever the director or producer or whatever.

The conductor of an orchestra is there to keep everybody playing in time and not too loudly. The director in the theatre is the opposite, more anxious about actors getting to rehearsal on time and speaking up when they get there. The orchestral conductor is very often an instinctive performer himself. This is highly evident during the performance, even if the audience sees only his back. They spontaneously relate to him as leader of the evening's proceedings and he is often its star performer.

Leonard Bernstein comes to mind. Dare any orchestra upstage him? Or Sir Simon Rattle? Orchestral players can play without a conductor, but they may not play as well or as tightly as when under the baton. Actors could rehearse by consensus perfectly well, but there would be an inevitable clash of personalities and egos and valuable rehearsal time would be swallowed up in their assertions. Self-discipline is always the hardest to attain.

The audience can only judge on what it sees, and it can only see the actors. Some directors, therefore, impose themselves on the production by adding extraneous detail to the mise-en-scène or loading it with complicated acting 'business', unnecessary visual or sound effects, uncalled-for textual cuts or alterations, and, on occasions, gross miscasting. All of this is done to underscore the directorial presence. If the director can't be there in person 'on the night', then at least the directorial intention will be evident. A heavy hand is only too clearly seen when it is laid on the production. It inhibits the actors, stifles their enthusiasm and diminishes their effect on the audience. This, of course, applies only to bad directors and there are bad directors as there are bad actors, but the trouble is that a bad director can cause more damage. A bad actor can always be 'acted over' as actors say, which means they can move around him, whisper his cues or come in fast on his response. This is damage limitation in action and is not often practised.

The question arises, do the actors on stage really need a director at all? Left to themselves would they manage? I think so. What is not generally known is that actors have a heightened sense of self and group discipline. The good ones are not fools, they know that what is good for the play is good for them individually and they work willingly towards that end. What is extraordinary is that actors who are not even speaking to each other off-stage yield to this overall requirement unstintingly. The audience is hardly aware of the hidden hostility between the lovers or the sharp words that have just been exchanged in the dressing room between the loving father and his on-stage son. If everything is not forgiven, at least it's forgotten for the duration of the scene. The play is still the thing and it always wins over any personal consideration. It takes a considerable skill to embrace someone on stage and appear to mean it, especially when that someone, only minutes before had cast doubts on that colleague's legitimacy.

The actor is essentially charitable to other actors on stage. They are in the action together and must necessarily lean on that comradeship for common survival under the lights. During the two-hour traffic of the play, they are in a sense bonded, free, for once, of the director, the agent, and all the externals of their craft, they can give themselves to the moment in front of the house. This is what they are there for, what they have trained for, what they are paid for, and its demands are absolute and all embracing.

Even the strongest director has no power over dressing-room relationships. Like all children, actors are quick to make up, but, like children, they need constant supervision. Hence our need of direction. The great directors were, and are, great inspirers. They pay the actor the compliment of being an artist at heart and of having some meaningful input into proceedings. The good directors hint, cajole and nudge gently and before you know it, the actors are doing exactly what he wants. Whereas the fascist directors live by direct order. The word 'Why?' is regarded as an insult to their authority and they go into a rage at the first sign of dissent. Perhaps they feel they are on such flimsy ground themselves that any questioning of the direction would expose their inefficiency and bring down the whole production – as does happen from time to time. Significantly, they arrive at the first reading with every little move written in their script *in ink*. Instead of a prompt book, which is arrived at gradually through the hours of rehearsal after trial and error and mutual conference, this is the Holy Bible come down from on high, sacrosanct and unchangeable.

One sign of a good director is the attention given to the small-part actor. The best directors know that the most powerful engine relies on the smallest cog and they understand that if they can restrain the inexperienced actor from doing too much, the older actors would do enough and a balance would be achieved overall. Any director knows that the good actors will always survive without him. George Bernard Shaw said much the same thing in 1897, when in a newspaper notice, he advised that 'managers should mind the minor roles, the leading parts can take care of themselves.'

Crowd scenes can be a large part of any production and the better directors get the best results because every bit player is treated as if he were a responsible actor with a vital part to play.

The Scottish director, Bill Bryden, previously mentioned, wasn't an actor but he found no difficulty in making his meaning clear to actors by taking them into his confidence in many superb productions in Edinburgh and Glasgow. Bill saw the larger picture and relied on his performer to fill in the details. Similarly, the late John McGrath, a Liverpool Englishman with a great love of the Scottish story, created epic theatre in a disused tramway shed in Glasgow by writing large, powerful actable scripts and casting them well with actors whom he made almost family. But the tall, good-looking John, for all his gifts as dramatist and director, was not an actor. Wisely, he chose to play to his strengths, as all good players do, and 'a good night out' was the result.

The limited director on the other hand fawns on the stars and is openly disdainful to the smalls. The actors in the mid-range were tolerated – barely. At one rehearsal in London, one such director was trying to convince a very experienced and amenable actor, but not the star, to mime opening the door on his exit. At this stage of rehearsal the door didn't exist but was marked by a gap in the tape on the floorboards of the rehearsal room.

'Why?' asked the actor. There was an immediate expostulation from the director, who, typically, wasn't on stage with us, but stationed with his cohorts around the table set up in the stalls. 'Then we can see that you are going out of a door,' he called out. 'Naturally, I'm going out of the door,' replied the actor evenly. 'I wouldn't walk out through the set.'

'I must insist that you mime the action,' came the voice from the stalls, wishing it had a microphone. The actor looked nonplussed.

'Isn't that a bit silly?'

'SILLY?' The sound had apoplexy written all over it. 'Are you questioning my direction?'

'Not at all, old man. I was just–'

'Please do as I say, and MIME.'

'Very well,' said the well-known actor quietly.

Going up to the marked door, he 'opened' it beautifully in mime and going out he turned and mimed closing it just as neatly. Then he stood in that position, took his script, closed it and bending down he expertly mimed pushing it under the door. Then he stood up.

'What *are* you doing?' yelled the director.

'I'm handing in my script.' replied the actor, still very calm. 'And if

I didn't think I would dirty my fingers, I would mime coming down there and sticking it right up your arse. Good morning.'

Just as the great football player will improvise on the football pitch, so the good player on stage will turn a line unexpectedly to good effect because of audience response or because of an unlooked-for laugh. He will earn a wry comment from the director at the interval, but if it has worked you can be sure the good director will say 'Keep it in.' Similarly, Sir Alex Ferguson might come down on the star player from deviating from the game plan but if the player scores as a result of his initiative, he'll get a wink and a pat on the back. Good managers, like good directors, know when to give their gifted individual players their heads. The actor has reason to be grateful for this on occasions, but also knows, despite the director's control and authority in rehearsal, in the end it all comes down to the actor and audience exchange at the moment of performance just as it does for a footballer with the ball at his feet on the field with thousands roaring him on. Like the football player's, the actor's arena is also a place of dreams.

Who's Nervous?

HISTORICAL ASIDE

1642: All theatres were closed by the Puritans. Alternative 'enter-tainments' were offered by managers 'in the manner of the Ancients'. Inigo Jones designed masques. 1656: 'The Siege of Rhodes' an 'opera' was presented, introducing the first recognised English actress, Mrs Coleman. 1660: The restoration of the monarchy. Charles the Second grants theatre patents to the Duke of York's Men and the King's Men under Davenant and Killigrew. The history of Restoration Theatre is the history of these two companies. The French influence was felt in the rapid promotion of actresses although the boy actor, Edward Kynaston, was hailed as 'the loveliest lady ever seen', but the genius of Thomas Betterton dominated the Restoration stage until his death in 1710.

NERVES FOR THE ACTOR go with the job. As constant companions, they take up lodging in the actor's person from the time of the first run-through and take over completely as the first night approaches. Some think they are permanent, non-paying guests, for the outward signs of their presence – spiky temperament, hyper-sensitivity and downright bad temper – are to be seen in the citizens of make-believe whenever they are engaged in the end-stages of their calling. And it's not only the actors. When the opening is upon them, the tension quickly spreads itself like a miasma through the building. The stage-door keeper picks it up from the actors as they come in and passes it on to the fireman and he takes it backstage when he does his rounds and before long everybody's tense.

Stage fright is very real for all actors and when it becomes acute, the only recourse is a hurried, if fervent prayer. 'God' is a word not exclusive to churches. 'Oh, God,' is a frequent actor's ejaculation and 'Oh, my God,' is heard when things are more serious. Even the most pagan actors have been known to use both at once in emergencies. 'For every

man,' said Hamlet, 'hath business and desire, such as it is; – and for mine own part, look you, I'll go pray.'

The putative patron saint of actors is St Genesius, reputedly a Roman (in the ethnic sense) who stepped into the arena to impersonate an early Christian during the Diocletian persecutions and was martyred for his pains. He had joined the luckless Christians in order to ridicule the luckless victims, but fired by their sincerity and courage, or else by the Holy Spirit, he found himself allying himself with them and was baptised by blood, his own. Unfortunately, Genesius, along with St Christopher and St Nicholas (Santa Claus), has since been discredited by the Vatican, but that doesn't stop some perspiring actor, standing in the wings, having a hurried word with Genesius or his Maker.

The late Herbert Whittaker, who was a Canadian theatre critic and stage designer, composed a moving *Prayer for the Artists*, from which the following lines were devoted to the actor, *'And please God to remember the actors moved by spirits other than their own and those who attend and lead them...'* Mr Whittaker was obviously much acquainted with the histrionic species and understood how much they are a medium of their message, and therefore very much at the mercy of the moment. If the thespian efforts succeed and the audience is persuaded of their spontaneity, then the spectators believe that what is said in the dialogue is natural and improvised at the moment. Very often it is, but the audience is not to know that.

The truth is, especially before the play begins, the actor needs all the help he can get, from whatever source or whatever religion, as 'curtain-up' looms. The young actor only prays to be the best on that night and that the big agents and film casting agents will be out front to see it. Buoyed by an excess of self-enthusiasm, not a thought is given to the possibility that anything will go wrong in the performance. What was the point of all that study and those long, detailed rehearsals? Like a racehorse in the stalls, the young actor can't wait to get started and let the public see how lucky they are to witness it.

The more mature actor, however, knows there is a chance that things *might* go wrong, especially in that tricky exit with the tea tray. There is so much pent-up energy in the air, an alchemy of unseen forces at work, all the basic elements of human doubts and fears that the experienced player crosses his fingers, rubs the rabbit foot always carried somewhere

on the costume, turns round three times on the spot or goes through any of the other arcane rites actors devise to ward off the evil eye that they know might be willing their imminent disaster.

The old actor doesn't bother himself with such silly rites. He *knows* that something is bound to go wrong on the night, and he only hopes he can cope when it does or that he's not on stage at the time. He remembers the old actors of his day who were so resourceful that nothing fazed them. One leading man made sure there was a bell in the prompt corner. If he dried badly, he would say something nonsensical or non-sequential. This would warn the prompter on the book, who would signal stage management to ring the bell upstage. The actor would then move upstage as if to check the sound, and looking off, see the forgotten line scrawled on a board.

In the contemporary, modern-dress play, there would be a telephone on stage, instead of an off-stage bell, and when it rang, the actor, wearing a suit instead of a toga, would pick it up and, while the cast looked on, improvise a conversation while listening to the prompt coming through from the corner. When he had registered it, he put the phone down, apologising to the imagined caller for having to ring off, and calmly continued where he had left off. Today he would carry a mobile phone in his pocket.

It was a modern actor who told me that the soundest piece of advice on how to deal with first-night nerves came from a non-actor, a lay person, who was anything but theatrical. They were sharing a compartment on the train and the actor was going on about the problem of first-night nerves.

'Look,' said the stranger, 'even if you do make a right mess of it, you have to do it again the next night, don't you, no matter what happens?'

'And the night after that,' replied the actor. 'And after that again, if you're lucky.'

'Well, you're bound to get it right eventually. That's your job, isn't it?'

Another member of the public was not so understanding. He made his comment during the run of a very successful West End play when one character standing upstage centre on look-out turned to ask another member of the cast, 'What time is it, Sergeant?', And before the Sergeant could reply as per script cue, a loud Cockney voice, with all the resonance of a Covent Garden porter came booming down from the gallery, 'Time you lot knew bet'er'.

It was some time before that cast got back to work.

It is often hard for the non-actor to think of acting as real work. Not work as stoking a factory furnace is work, or being a fisherman at sea, or worst of all, a miner down a pit. If an actor really examined his clammy hands in the wings, it would be easily seen that they had never done a real day's work in their lives, real hard labour that is. By the same token, it might be just as hard to imagine the furnace worker on stage in tights or the fisherman dealing with a sonnet or the miner coping with words to learn. There is a good chance that the actor could do their jobs, after a fashion, but could they act? Too often, the very gift of acting talent is taken for granted, even by actors, but it is not something that comes in the post.

There may be an acting gene, famous theatrical families are proof of that, but generally speaking, acting is a skill discovered by accident and developed by chance. It may be assisted by solid application and further honed by experience, but so much of acting as a career is in the lap of the gods, and at the whim of so many factors beyond the actor's control. Actors are always aware of this. This accounts for a certain volatility of temperament. With only a finger-tip control of his own destiny can you wonder that the actor has to learn to make the most of the moment. And by far the best moments of his professional life are spent in rehearsal.

Rehearsal time is the actor's play-time. It is a period that belongs entirely to the performer. Without the presence of audience or critics, or any vestige of the outside world, the actor can enjoy the freedom of failing, of making mistakes, in the company of friends, as together they search for their characters as scripted. It can be a joyful progress, it can be a trek, and occasionally, a Calvary, but it is gone through assiduously, with laughs most of the way, and what tears there are can be brushed away. It is an invigorating exploration, using every intellectual muscle and emotional fibre in the actor's body to find that one little clue that will reveal the wholeness of the character to be played.

This is more than finding the right hat or correct walk, this is mind matter and has to be pursued rigorously. Research has to be undertaken, books read, advice sought, night lights burned as the search goes on. It's more than learning lines, it's to know what goes on under and around the lines. The lines are just the bones, the actor has to find the blood. The academic qualities needed here belie the notion that the average actor is a superficial exhibitionist. What is exhibited is the performer

self underpinned by reading and coloured by intuition and instinct. When the actor does this in a company of actors all doing the same, the energy levels are high and the excitement in the air is palpable.

The rehearsal room is always warm when things are going well but when they are not, icicles form. There is often a stage in every rehearsal when the production falters. This is only because the ingredients involved are all human. The certainty felt at the first reading imperceptibly wilts under the weight of investigation as each line is tested, every nuance checked. Some actors sail through this stage. They are 'quick studies', but many are not. They are the word worms. They make their way inch by inch through the script while the 'quick study' looks on impatiently. It can affect company morale as it makes progress uneven, but this is when the good director comes in. A word here, a suggestion there, better still, a smile or a laugh, the flame is re-ignited and the icicles melt. Things go forward in a great surge, and a feeling of elation engulfs the company as things begin to knit together.

Each jigsaw piece must find out best how to fit in with the rest so as to make the complete picture. This is an exhilarating time for all concerned, as shapes are made, corners smoothed and the overall pattern becomes clear. It is team-work of the best kind and brings a real elation to the work when the part becomes part of a whole and the dramatist's hopes are realised in the shape of flesh and blood people who speak and move as the lines dictate. It is impossible, of course, to completely inhabit the playwright's mind, but actor and director between them have a good try in rehearsal time.

Each individual component actor sees his or her place in the scheme of things, and what is required of them in the final push towards the opening and this is a further release. Suddenly, all the bedroom study, private word cramming, collegiate copying or whatever, pays off and like a squadron of planes in formation, the company takes to the air. Every plane is its own character, each actor a pilot at the controls, and guided by the director on the ground, they soar into their make-believe sky.

There are no nerves at this point. None is needed. They won't come until first night. Meantime, the actors can enjoy the emotions they engender, they can *really* feel what the words represent and once they have registered that, they imprint the physical picture of those memories in their minds and reproduce it at will in performance. It may only be a

look, a gesture, a turn of head, anything that will signal the appropriate emotion of that moment. This can only be felt in rehearsal. Personal feelings have no place in performance. Only the externalisation of the rehearsed feelings is required. It's called acting. And that is why it has to be worked at before it is fit to be presented to an audience. Voice, costume, mise-en-scène, all come together by the first dress run-through and often the best performances emerge then, because everyone by that time is relaxed and in tune with each other, and, as yet, not exposed to the public. The theatre cleaners often see the best of any production.

Most lay people can't understand the haven that the rehearsal room is to actors. Here, they can let themselves go, let their hair down, be themselves as they start on the trek towards the character they have been hired to play. The actor can do no wrong in rehearsal. It is here that real tears will be shed when called for, real emotions felt, real feelings explored as per script – all to be remembered and replicated later. Arriving at the point of tears in rehearsal, paradoxically, can be joyous work, for everyone is on the same wave of discovery. Of course, real tempers will also be lost, hard words said, immediate apologies made, but frailties are dealt with on the spot, egos demolished with a laugh. Under a good director, the actor can try anything, play the fool, go too far, have a ball. Experiment is encouraged, because friends are with friends in a common purpose – to find the play that lies behind all those words given them by the dramatist.

Yet the irony is that often the best acting requires no words at all. A theatre axiom is that good actors speak well but great actors listen better. Even in rehearsal, the better actors work at listening. It is an art. Another actor may have had the burden of all the dialogue, but one's eye goes to the actor who is standing rock still in the scene, saying nothing. By absolute economy, the meaning of silence is made clear, and watching actors imagine they can just see the tiniest flicker of an eye, the very edge of a smile. Silence is a fantastic actor when it is controlled and well managed. In the big moments, words just get in the way.

People think of the voice as the actor's surest weapon, yet when the experienced performer chooses not to use it, meaning can be suggested by a shrug, or the smallest shift of look. This is what makes the theatrical trade a continuing fascination. How is the unnatural made to seem so naturalistic in the acting situation? How is the outside self of the actor

so well served by what is inside that self and without a muscle being moved? It's a mystery, and it gives the actor a special mystique.

All actors dream of a good part in a good play with good colleagues for good money just as they have nightmares about an awkward part in a difficult new play with an indifferent cast on shares for a trial run. The reality is nearly always between these two extremes, but there is no doubt that rehearsal time is the happiest time of an actor's life. Work is a joy when it is totally committed to and causes the creative juices to flow in conjunction with others who are working in the same way.

All actors, too, have known, at one time or other, the magic moments in rehearsal when the books are down and one actor decides to 'take off' in the big soliloquy and flies up among the angels. It is a heart-stopping moment for the cast, standing near or sitting around watching. Even the director's jaw has been known to drop. The good actor registers this golden moment and puts it away in his subconscious, hoping it can be brought out again in the same way before an audience.

Yet, in the end, what serves the actor best is a sense of humour. When television started in Britain after the Second World War, one actor is reputed to have said to another, 'I can see a whole new field of unemployment opening up.'

Beyond the bare, wooden floor of the rehearsal room, the outside world keeps turning. Wars are waged, presidents are elected, cup finals are played, babies are born and parents die. These things impinge on actors as they do on everyone else but their view of such events, at least during rehearsals, is with the telescope turned the other way round, or with their volume control on the world's doings turned down low. This doesn't mean they are indifferent to their place in the world, far from it, but they have to assert other priorities during this important period in their working lives. They often come out of rehearsals somewhat surprised to find the outside world is still going on.

Actors have played in comedies after burying a parent. This doesn't make them heartless or unfeeling, or lacking in a proper respect, but it is an in-built response to a priority. The show must go on, and so must the performer, unless in the most extreme circumstances. It would be hard to concentrate on anything after losing a child, for instance, but the actor is given the right to grieve if need be, and the understudy is brought in. The understudy is there for real emergencies, but it has to be

real if the working actor has to be 'off'. The actor feels duty-bound to 'go on', even if feeling quite ill, and on he goes, spreading his germs all over the first three rows of the stalls. But he gets his laughs, or his effects, and comes off feeling much better.

The therapeutic value of performing is too often undervalued. Even if it's only for the two-hour stage traffic, the actor is always the better for that contracted spell in wonderland. Having to concentrate hard allows a forgetting of everything else for a while, but everyday problems are still hanging up there on a dressing-room rail. One of the items in a pocket might be an NHS prescription because the theatrical demands made on an actor's mental and physical stamina over a long career take their toll. This is often forgotten. We must bear in mind, that actors are human beings before they are performers, so it's the body that feels it first. Collywobbles turn to acid, brain cells rebel at their workload, and limbs begin to resent the pressure put on them. Many performers down the years have cracked under these relentless physical and mental pressures, but significantly, more have not. This is because actors are treated exclusively by 'Doctor Greasepaint', who, to them, is the finest physician in practice.

'Dr Greasepaint' is the name given to that overwhelming energy surge that allows the actor to deal with any incapacity that might prevent him from making his entrance as per script. The greasepaint stick is the basic tool of every actor's make-up box. It comes in all colours and is numbered for reference. 5 and 9, the thick sticks, are favourites with Lit K for skin colour, and the thinner ones, lake for shadows and white for highlights. Greasepaint is the actor's greatest ally, which is why the cosmetic is the synonym for all theatre's best effects. Dr Greasepaint has a cure for everything, except toothache, which actors will tell you, 'is a bugger to act with'. Hay fever can also be a problem, especially if real flowers are used on stage, but this is usually found out at dress rehearsal. Incidentally, in a long career in the theatre, I have never heard, or heard of, an actor's sneezing on stage spontaneously.

It is no accident that colic, with all its concomitant stomach disorders, is known as the Actor's Disease. Butterflies in the stomach, endured night after night for years, but especially on First Nights, will inevitably turn back into grubs. Actors have their own quick nostrums, nearly always available at the nearest hostelry, rather than the chemist's, and

these, of course, raise other problems. The drunken Duke of Buckingham in the play isn't the only offender in this respect, as many a front row has known to their cost. It is a fact, however, that nerves are a real problem and it's something every actor has to face. Panic attacks are common and may happen at any time, at home, in the dressing room, even during a performance. It is then that trust is put in the work done in rehearsal. If the character is soundly based, it will weather the unexpected squalls that nerves can bring to every performer.

What is worse is that it is recurring. Even on the second night, which is often an anti-climax and a slough to get through, depending on the critical reaction, there is still a residual tension. The perennial cry of friends on the first night, 'You were wonderful, darling', has gone down the cul-de sac where all clichés belong. Acting is a deed that has to be done, an enactment that has to be gone through nightly until the end of the run. This is the main event of any actor's day, its culmination, the end game which is played nightly. It is a happening that cannot be avoided, and it looms up in the actor's subconsciousness as soon as twilight hints at night. That's when the stomach feels its first twinges of dread. Whatever they are doing at that time, all actors stop and think of getting ready for work. They must prepare to don the mask and embark on what is their gainful employment. It's not quite the execution it may sound but there's no doubt that during the run of a play, the play hangs over every actor's head like an axe.

They're in work. Why can't they be happier about it? The answer is that they're dealing with something imponderable that might rest on how they, the cast, feel at any given moment during the performance. They've worked hard to get this far, buckled down to rehearsals, given their all at the opening, and it was well received, yet still the doubt remains. They must wonder at times if it's worth the strain. Of course it is. The tension is there because they are dealing with sensations, with human feelings, the actor's own as well as those of his co-performers, not to mention those of the audience. Such things can't always be dealt with by the yard or by the ounce and ladled up over a counter. This is delicate commercial congress involving the purveyor (the actor) and his paying customers (the audience) and the reason why he sets up the bargain to entice them into his shop.

Pretend passion is used to excite passion, mock laughter to provoke

laughter, rehearsed tears to cause tears, and every trick in the trade to inspire wonder. It's a fair agenda for any tradesman and actors must be, or seem to be, on top form to pull off their part of the bargain. They will feed off themselves, in a sense, to feed the body of people gathered to watch. That's where the strain bites hardest. No wonder reaction sets in afterwards. This shows itself in the state of euphoria and exhilaration, which every actor feels at the end of every show, no matter the mishaps met with en route. That's another 'house' sent away smiling or thoughtful, another catharsis attained.

There is an immense professional satisfaction in helping to entertain, amuse, uplift or edify another motley group, even though motley is the actor's accepted uniform. Adrenaline is potent medicine and if not long-lasting, at least, it is quick acting. Which is why the dressing room after-wards is rarely a wake, even when the company knows it has a turkey on its hands. The actor is always ready to 'party', especially when he has wiped the make-up off his face.

This is when his behaviour is most 'actorish'. When he is excessive and talks too quickly and too loudly. 'Seats' don't realise he has to burn up a lot of unused energy he had stored up for the evening which is why he is so ready to celebrate. First Night parties are almost a theatrical genre in themselves. The intoxication induced via the bottles available is often less than that experienced by the actors as they take the curtain call. The psychological release felt by the play's having been done is enough to induce a real hysteria in the cast, no matter how it's gone. One 'big-name' was noted for the idiosyncratic way in which he took his call. He would bow low in the line up swearing like a trooper under the applause and come up smiling. He had just given a wonderful perform-ance and probably was quite unaware of the invective that was streaming from that famous mouth. It was only a symptom of reaction, his way of letting it all go. Another recent 'great' could not be consoled in the dressing room afterwards and sat sullenly at his mirror while people crowded in to reassure him that he had been wonderful. 'I know that, I know that,' he would shout, banging his fist on the dressing-table, 'But why? WHY?' It would take this whole book to answer that but it was his way of asking exactly what he had done and how he was going to repeat it next night and the night after that. It was also his way of coming down to earth again after being high. He was prone to this reaction on

first nights. Nobody ever tried to answer him. Afterwards, he was the life and soul of the party.

Dynasties have been founded at first night parties, and just as many marriages have been broken up following the after-show celebrations. If the actor is vulnerable beforehand he is just as bad afterwards. The difference is that he carries his pre-show anxieties into public view in the play but his private self takes over when the curtain comes down. At such times, exhaustion is pushed aside and few would guess that this non-stop talker holding his glass is a tired soul who has been drained by a night's exertion on stage. The trouble is that energy levels are restored by also draining the nearest bar or restaurant of its entire cellar. Fortunately, everyone understands and forgives a sudden keeling over. The nearest couch is utilised and a taxi is called. Those of a stronger constitution sit and gossip the hours away until the papers come out or best of all, leave the party altogether to walk home alone in the cool, early morning with only cats and policemen on the empty street.

To walk home, or back to digs or hotel room, with thoughts only for company after a big opening is one of the best moments an actor can have, especially if it has gone reasonably well. The relief is patent, and the sense of survival is strong, but most of all, it's the feeling that despite the nerves, the tension, the nausea, it has been got through and the audience appreciated his efforts. Every line is re-lived again and every laugh re-played in the head to give way to the memory of the good silences. Even if a couple of lines were mucked up and a few effects missed, they were covered up and nobody noticed except the ASM on the prompt book. There were many more things that did work and tonight it will all be gone through again..

Sleep is difficult to come by. Thinking of people at home is hard. They are the actor's real world but somehow they don't seem to belong to this time. It was hard to come down from the clouds, to step off the stage, come down from that make-believe journey made earlier with friends in the company of strangers. It was just another first night among many. It is hard to think of the number of parts played by now, the costumes worn, pages of lines learned over the years, the number of shoes walked in over so many stages since that first first night, when the career odyssey began. Career is the word, bouncing from part to part like a pinball machine. Sleep comes with the hazy but reassuring feeling that, if only for a night, you have been

totally justified. Some once-read words from Eleanora Duse, a famous, old-time Italian actress, waft up around the pillow,

> *'The actor, in playing his role on stage before an audience at a given time, is not the agent of a deliberate intention, he is the intention itself...'*

So be it.

Is there an Audience in the House?

HISTORICAL ASIDE

1713: 'Cato' by Joseph Addison, editor of 'The Spectator,' heralds the arrival of neo-Classicism and a return to Greek and Roman themes with a parallel resurgence of pantomime and the ballad opera. 1728: John Gay's 'The Beggars' Opera' was the first and best of a long line of plays with music. 1737: Henry Fielding's theatrical satires against Prime Minister Walpole's Government of the day prompted the introduction of The Theatre Licensing Act giving the Lord Chamberlain full powers over whatever may be presented on any stage in Britain. 'Any person acting for his own gain without licence shall be deemed a rogue and a vagabond...' All new plays must not be acted without being approved by the Lord Chamberlain. Only those companies conforming may be considered legitimate. Censor morum had arrived with a dull thud until a new Theatres Act allowed 'Hair' and 'Oh Calcutta' in 1968. Anything goes now.

STEVEN WRIGHT, AN AMERICAN humourist, asked, 'If all the world's a stage, where is the audience sitting?' Had he been an actor, he would have known that the audience sits right at the front of any actor's mind at the time of performance. They are the first priority. Not that all actors appreciate this. Some, believe it or not, actually hate the audience, especially the kind that come to the theatre in fur coats and bow ties to be seen rather than to see what the actors had to offer. This kind of audience is seen as the enemy to be won over rather than as friends who are willing to become engaged by the theatre act. After all, if people make the effort to attend in the first place, it might be assumed that they have made the first move towards complicity. Even the fur coat brigade will yield to sheer attacking talent and artistic determination, but with

this obstinate kind of audience, it is always a battle. However, this is not every actor's experience.

The first factor in that experience is the audience. It is for the audience that the play itself is made. It is not made to show off the talents of the actors, however gifted. Assorted human beings gather at an appointed time in an appointed place to witness a demonstration of apparent life by a group of other human beings and this fact, it must be stressed, is the sole reason for the actor's existence. A theatre without an audience is only a building, an actor without an audience is professionally a cipher. It was the audience that created the need for the actor in the same way that the actor has created an audience for theatre by responding to its need for the common or group experience.

This is that action and reaction that can uplift, edify and, above all, entertain. In addition, the audience is also the definer of the actor's effectiveness, the decider of theatre careers, and therefore of importance to lives other than that of the performers on stage before them. It is a large responsibility for people who are only looking for a night's enjoyment, but the fact remains that theatre belongs, in the beginning and at all times, to the audience and not the actor.

The audience as a term is best considered as singular but it is a state arrived at only by the end of the specific performance. In answer to it, a diverse collection of 'elbow strangers' who vie for possession of the seat rest at the start of the evening, leave the theatre as a collective entity bonded by the impact the play has had on them, not as random individuals, but as a collective whole. Once its action takes hold, the individual seat-holder forgets any earlier social inhibitions and positively rubs shoulders with the strangers on either side, no longer strangers but boon companions on the journey the audience as a unit is about to take towards the final curtain. It arrives at this as one if all goes well. 'They' are now 'it'.

However, this happy metamorphosis takes time.

The audience can never be blamed for its reaction, whether hostile or friendly, because it never acts as itself, it responds solely to being acted upon, and does so spontaneously and truthfully. There is no such thing as a bad audience, as such. There are bad plays, and from time to time, bad actors get on stage, but an audience, in itself, is never bad. It can become so, made so by the indifferent fare put before it, but it begins faultless, a pure, untainted sheet put before the performer, and

one on which the message of the play has to be imprinted. This is the first great lesson any professional performer has to learn, how to manage a 'house' as the audience is called. How to 'read' a house and how to let it 'tell' the actor what to do is a vital lesson in stagecraft that has to be learned by experience. A good audience is the best drama teacher there is.

The audience is called many things by the performer, especially during the performance, but generally speaking, it is only as good or bad as the actor makes it. One actor very properly responded to a member of the audience who said to him after the show, 'I must be honest, I don't go to the theatre often. I resent being manipulated by actors.'

'On the contrary,' the actor told him, 'We are the ones manipulated by you.' How true that is, but the audience is rarely aware of it. The audience response is not only in tacit control, it is the performance gauge, the only true reflection of the cast's effectiveness, or lack of it. Which is why the actors will say, after a poor performance, 'It was a real stinker tonight,' but after a good show they remark, 'It was a lovely house tonight.' The truth of course being that the audience was a stinker only because *they* (the actors) might have been off-form and the audience was lovely because the company was good. A poor house to an actor is more of a quantitative description as it refers to the numbers in that night, just as a great house is a full house. No actor enjoys playing to a handful.

The audience is always embarrassed by its own skimpiness and the actor is conscious of this. When the audience has no sense of bulk, it feels threadbare and. consequently, is inhibited in its response, and so the night fails. Mrs Patrick Campbell used to refer to these dead nights by saying, 'I see the Marquis and Marchioness of Empty are in front.' Nobody enjoys their company, least of all the actors, but an audience needs to be reassured by its own mass so that it feels safe and comfortable in its very weight. Lack of numbers reduces the audience to its individual components and this compromises its effectiveness. A scattered audience is splintered into its individual components and thus denies to them the sense of sharing that is a prime part of the theatre experience. A near empty house is not only draughty it is a vacuum, but only for the producers, who obviously will not 'clean up' on this particular production. It not necessarily a disaster for the actor.

Many a tiny audience has been known to 'spread out', literally, by

putting their coats in the seat beside them and, moving up one, placing their arms along the backs of the seats beside them. This is not the audience as enemy, but as friends. The actors feel this warmth rise up on to the stage and they respond by giving of their best and the evening is saved. Figuratively speaking, the energy created in this way can fill a theatre and the empty seats are never noticed. The final dictum for the actor is always, 'where two or three are gathered together' but this is not to be taken too literally of course.

What actors call a 'paper audience' is almost as bad as having half a dozen in the stalls. 'Papering a house' means the management has given away handfuls of free tickets in order to build up an audience, and it is not the best decoration in the actor's eyes at least. People who get in on complimentary tickets have a different attitude to those who have paid. They are more difficult to 'capture' as they are usually not regular theatre-goers and hold out longer against the actor. There is always one of this type in every house and in the quietest, most serious moment in the play, theirs is the voice that is heard saying in a loud whisper something like, 'Oh dear, I think I forgot to turn off the oven.' It takes great drama to recover from moments like these.

Given time over the evening, all kinds of changes can happen to and within an audience. It has congregated, not to be hectored or preached at, but to be entertained, which means to be energised by artist practitioners whose art is revealed in the 'act' they perform for that purpose. This is where the mystique of acting is applied to the mystery of story, and in so doing, can change an audience even as it sits there. They call this little miracle 'catharsis', by which suppressed, or latent thoughts and emotions are brought to the surface and purged. This is the actors' responsibility but they must never be intimidated by it. Whatever goes wrong in the action, they should have the skill and confidence to keep their on-stage worries to themselves, and never on any account to panic.

'If you panic, they'll panic,' young actors are reminded by their practical seniors, 'Seats can smell a frightened actor from the back of the stalls, and they don't like that. They didn't pay good money to sit and feel uneasy. They want to enjoy themselves and they don't want to see you shitting yourself.'

Experienced actors know that the audience works as hard as the actor as the night progresses and is often away ahead of the cast. Each

must try and keep up or try to catch up for both actors and audience are under contract to the evening. The former are paid to attend, the latter pay to do so. This creates a liability on both sides. The actors want to earn their pay, the audience has no wish to waste its money. It keeps its part of the bargain by sending a collective energy up to the cast just as much as the actors send a reciprocating energy down from the stage.

This action and reaction between the two is the making of the circuit, that on-going exchange between actor and audience that is the traffic of the night. They are co-performers, partners in the dual process that is at the root of the whole enterprise. There is a mutual dependence. Each works for the other and if either partner defaults there is an immediate short in communication, a fuse occurs, and the play, in a sense, blacks out. Actors and audience alike sense this at once by the sudden change of temperature. Once any breakdown happens, it gets colder right away and if the actor doesn't stoke the emotional furnace quickly then the action freezes, and everything grinds to a halt. This is seen clearly when someone 'dries' or stumbles over the dialogue. A chill of embarrassment seeps through the house and everybody goes rigid. It is painful all round and the only way to deal with it is to get a big laugh as soon as possible or bring the curtain down. That is only in extreme cases but to actors, this horrible moment is always extreme, and the nearest they ever come to the death wish.

Colleagues always help out of course, but often they are late with the life belt and the poor actor is left drowning in a rising tide of helplessness. So is the audience. They feel for the actor and squirm in their helplessness. Which is why the actor must do everything he can to cover any slip. The audience must never be allowed to feel any pain, even if he means the performer must squirm for a bit. In the long run, as they say, it will be worth it.

There was one occasion when one old actor 'laddie' found the big armchair on the set so comfortable under the heat of the stage lights that he fell fast asleep on stage. The young actor in the scene with him was at a loss at what to do. After ad libbing lamely for a few moments, and following frantic signals from the prompt corner, he just crossed over the carpet and shook the old actor awake.

'Oh, I say, did I fall over?' the old fellow asked quite naturally.

'Yes, you did,' answered the young actor honestly, a little take aback.

'By Jove, I must have had one too many at dinner, eh?'

'Yes, perhaps you did.'

'Well, no harm done. I mean I didn't burn the house down, did I?'

'Well – er – no.'

'Right, then. So what were we saying, before I drifted orf?'

It was the young actor's turn to think on his feet but the audience took all this as being quite natural in an exchange between a young man and his grandfather and was not at all discomfited by the interlude. It was all done so spontaneously that the departure from the script was only noticed in the Prompt Corner. As it happened, the director of the play happened to be in the audience that night and he liked it so much, he told the actors to keep it in. It's not known what the playwright thought.

If such insertions are unethical or against the rules, the artist in any discipline knows there are no rules or formulae in performance other than the simple need to do it, and for the actor, that means to be seen and heard. No audience is totally intractable. It *wants* what is presented to them to be good and will usually do anything to help the cast get the desired effects. They will receive the full benefit of any doubt, and the audience will think them wonderful until the cast, by their own efforts, proves it wrong. This is why the actor can take all the time in the world to open the play, for conditions of reception will never be so favourable again in the night. And one needn't be a star to savour such a moment.

One of the finest openings to any play is that provided by Shakespeare in *Antony and Cleopatra*. It is very simple but it is one of the few good opportunities offered to the supporting actor, and they don't come too often. The script says:

ACT I, SCENE I – ALEXANDRIA. CLEOPATRA'S PALACE

(Enter Demetrius with Philo. Philo is speaking as they enter.)
'Nay, but this dotage of our General's
O'erflows the measure. Those his goodly eyes
That o'er the files and musters of the war
Have glow'd like plated Mars, now bend, now turn,
The office and devotion of their view
Upon the tawny front. His captain's heart,
Which in the scuffles of great fights hath burst
The buckles on his breast, reneges all temper

And is become the bellows and the fan
To cool a gypsy's lust.
(A flourish sounds)
 Look where they come!
Take but good note, and you shall see in him
The triple pillar of the world transform'd
Into a strumpet's fool. Behold and see!'

This is a directive given by Philo less to Demetrius than to the audience.

It is a brilliant stroke by Shakespeare to provide the actor with a mellifluous and speakable text, which at the same time gives an unerring micro-portrait of Mark Antony, subconsciously preparing the audience for what is to come. What is astonishing is that after getting the play off to such a fine start neither Philo nor Demetrius is seen again. That's Shakespeare, but, as the saying has it, a good beginning makes for a good end and it's good to see the supporting players getting the chance to shine.

'Behold and see!' The instruction is quite explicit and it really is all an audience is asked to do, apart from the Antonine exhortation from another play to 'lend an ear'. This is literally true and any play is a conversation in which the listener joins and assists by saying nothing. This requires a certain discipline, and the only rule is that one party in this considered conversation has to be quiet and let the other do all the talking. The non-vocal element, however, retains one instrument of comment and that is the cough. The first cough is a preliminary hint to the actor, the second is more serious, a warning, and the third is the rallying-call to all seats that action has to be taken. Laryngitis may be a threat to the actor's ability to perform, but even more ominous is a sudden epidemic of bronchitis in the audience. It has been known to kill the performance stone dead.

Any audience has to be wooed at the start, but it mustn't be a long courtship or the romance will never bloom. Audiences don't like actors who try to ingratiate themselves by way of performance. Audience respect must be earned by the player. It has to be won over by theatrical persuasion. The actor must seem to 'be' so effectively that the audience believes that he 'is'. Only then can it surrender to the play and forget itself in it. This is what makes it as one, and in turn to become one with

the players and so a complete wholeness is achieved. The actor looks out on them from the stage and at such moments the audience is as still as if painted into their seats. Actors call this wonderful moment 'being on velvet'. It is a beautiful experience for actor and audience alike.

You see, in the course of any play, no audience is ever completely still. There is always some kind of movement somewhere – a shuffle in the seats, a hand to the face, a leg changeover, a programme dropped – a constant series of little moves that looks like a choppy sea to the actors from where they see it. Then suddenly, a magic moment, and everything stills. That's when the audience catches its collective breath, and a hush descends. The actor can afford to speak in a whisper at such times. It doesn't last long, this golden moment, but when it does, everybody knows they have experienced something special.

This is where the real enchantment of theatre lies, in enticing strangers to come together in that other land, and live there happily ever after or at least until the houselights go up again. This is where feelings come into play, chests tighten, lumps come into throats and tears smart in the corners of eyes.

The audience becomes involved almost without knowing it and certainly without any deliberate or pre-planned intention. Straight theatre has no equivalent of opera's claque in the gallery. In what is still termed legitimate theatre, so-called from early Licensing Act days, the audience is more than capable of making its preferences clear without being paid for it. It is happy to applaud for free, and doesn't need to be hired to boo. It makes its derision clear in so many other ways – by growing cold, and distancing themselves from the action, which is further demonstrated by simply walking out. The actor rarely retaliates by walking off, but a definite pall falls over the stage. The dialogue gathers pace at once, as if everybody in the theatre that night wants to get home early. Fortunately, walk-outs, either on the part of the audience or the actors on stage, are not the norm although empty seats can be seen after the interval.

Without doubt, the audience is the most under-estimated ingredient in the theatrical experience and to an extent that perhaps it should demand equal billing. As has been pointed out, the play would be pointless without them. The audience is not an inert, passive, receiving entity, but a living, palpitating, active agent in the theatrical process. The end of all theatre is to serve them at the time of performance and all other aims of

the performer are subservient to this. The audience is not just a part of the theatre act, it *is* the theatre. In the end, the audience is all that matters.

Actors know that the assembly awaiting them out-front has already made an effort to be there. People have got up from their television firesides, put on their coats, got into the car, or caught a bus and made their way to the theatre and paid for their tickets at the box office. To join together in order to make an audience is a large gesture of confidence. This disparate collective has already played its part and now the actors must play theirs. There are as many kinds of audience as there are many types of actor, but basically the audience come down to a compact mass of eyes and ears, and actors can be thought of as one common voice. They reciprocate in this act of faith and make a memory of this night for all who occupy seats.

It could be said that all actors are memory makers. That's what actors do, they make memories for the audience to take away with their programmes, so that weeks, months, years later, theatregoers can take them out and see again, in the mind's eye, a certain scene, or feel the moment in a speech once more. People never forget being emotionally stirred, spiritually uplifted, or brought out of themselves by something said or enacted publicly. The Roman circus did this in the earliest times, as did public executions later, but a good play well acted does it better – and more acceptably. In a way, both actor and audience are memory makers.

Facing the Critics

HISTORICAL ASIDE

1741: Charles Macklin, the Irish actor, gives the first naturalistic performance as Shylock in 'The Merchant of Venice', playing 'the Jew that Shakespeare drew'. Macklin's pupil is David Garrick, the first truly great actor of the English stage who devotes his working life to writing about acting practice and teaching it to colleagues in his company at Drury Lane while playing all the great parts until he retires, full of fame, at 60. Meantime, Oliver Goldsmith had written only two plays, 'The Good-Natured Man' (1768) and 'She Stoops to Conquer' (1773) – the latter a masterpiece. 1776: R.B. Sheridan buys out Garrick's share in Drury Lane after the success of his own 'The Rivals' at Covent Garden. Other plays followed, like 'School for Scandal' (1777) and 'The Critic' (1779) and the first Drury Lane pantomime, 'Robinson Crusoe' in 1781. Money troubles end his theatre life and Sheridan retreats into politics.

WE ALL HAVE OUR CRITICS, in whatever field we till. It may be a colleague, or a friend (some of our harshest critics are our best friends). Whatever the relationship an opinion is given and we have to take it. They always say that it is given with our best interests at heart and that they are only speaking out because they want what's best for us. Do theatre critics think like this about the actor? I doubt it.

As David Garrick put it,

> '...thus actors try their art,
> To melt that Rock of Rocks – the critic's heart.'

The first intention of the art of the drama is to create a reaction in the hearts and minds of the audience, but the actor must bear in mind that every seat taken is occupied by a potential critic especially now in the internet age when everyone can post their reviews online. Professional

theatre critics may love the theatre and be knowledgeable about its practice, they could indeed be friends, and might even intend what they write as being for the actor's own good, but the critic's first loyalty is to the editor, whose loyalty is to the proprietor. Ergo, critics are hired hands, just as a performer is. The critic's first duty is to fill the newspaper or magazine space allotted and to do so entertainingly and, if possible, with style and wit. The actor understands this, and tries to appreciate the critic as a fellow professional, but at times it is very trying.

The actor tells himself that his detractors are liars or at least deficient in taste or sense, but to criticise, in its literal meaning, is to pass judgement, usually to find fault or censure, and the drama critic does this very well. It has never been known that beads of sweat break out on a critic's brow as he or she bends over his or her note-pad trying to catch some light from the footlights. Secure in their padded comfort, warmed by the producer's brandy or scotch, they can take a comfortable view of the heavy industry going on above their heads, but the actor knows they have it cushy. Critics are out of the danger zone, they are *safe*.

The critic is only doing a job as the actors are doing theirs. The man with the pen is an accepted part of the theatrical apparatus and is now built into the fabric of professional theatre. The male critic attends every first night much like that knight of old who came to the lists, seated on a charger armed with a lance to deal with the adversary put before him, but 'Sir Critic' is seated in an armchair, pen in hand, notebook at the ready, determined to bring down the enemy set out before him in all their splendour and array. The female critic may be less obvious but her subtle needle can be just as deadly. Both their tasks are plain, that is to estimate and define the quality of the artistic work revealed in the action witnessed and to comment on this by words set down on paper. Older actors used to reassure themselves by saying that even the worst notices are consigned next day to the local fish and chip shop and did more good wrapping up somebody's supper than by affecting the actor's rehearsed performance.

The very worst performance in a very bad production has never yet killed a critic despite the yelps of pain revealed in their columns. Theatrical lapses are not fatal to the beholder, although they might be to that particular performance and to that particular actor by shortening his working life. A really bad notice is like the common cold, it gets around

and soon develops into a pneumonia of apathy and disinterest on the part of agents, directors and producers unless the malaise is caught in time by a redeeming performance. All actors get a severe panning, as opposed to a rap over the knuckles, at least once in their career, but rarely twice, and a third time would not be lucky.

However, not all notices are bad. The very best critics understand performers and attempt to evaluate what the cast is after in the performance. They are genuine commentators rather than critics, and they aim to improve what they see not destroy it. If, however, the actor stumbles over the dialogue, or fails to remember it, then the job is not being done at its basic level and such a performance deserves to be 'noticed' adversely. If, on the other hand, the actor makes the lines sing with an extra something or hints at other, deeper meanings in the text, then he is going beyond the call of duty and similarly warrants acknowledgement appropriate to the extra talents displayed. The trouble is that all critics find it easier to blame than to praise, and, like all true journalists, they know that bad news always makes the better story.

Some writers on drama, like the early 19th century's William Hazlitt, for instance, who might be said to be the very first drama critic proper, love actors and are not afraid to show it. Although Hazlitt did admit once that he preferred the written drama to the acted version, but then he was principally a literary man. Critical company was good in his day and penmen such as Leigh Hunt, Samuel Coleridge and Charles Lamb, all had a good appreciation of what the poor mummer was up to. William Archer was another who took his Victorian and Edwardian theatre seriously, and being a Scot, did so with diligence and integrity, particularly when working with Shaw and the 'New Drama'. He did not favour Irving, whom he thought was mired in the old ways. Archer was well-named, his vision was pointed like an arrow to the future of playgoing. James Agate, in the Twenties and Thirties, was also appropriate to his name, for he was a crusty old stone of a critic, and the author of a whole shelf of theatrical volumes in his 'Ego' series. Could there be a better title for theatrical writings? For at the basis of all aesthetic enterprise is the ego. The late Kenneth Tynan, the *enfant terrible* of post-war theatre understood this and contemporaneous critics like J.C. Trewin, Jack Lambert, Sir Harold Hobson and Michael Billington all had the ability to spot the gold among the dross, and in Trewin's words, 'enjoy everything

from Sophocles to Max Miller'. Eric Bentley, on the other hand, had no great opinion of critics. In *What is Theatre?*, he wrote, 'for the journalist critic, the only alternative to a sharp tongue is a mealy mouth.' Perhaps W.S. Gilbert had the most diplomatic response to any performance. The acerbic writer's dressing-room standby to any actor was, 'Good is the only word.'

In modern times, there have been thinking actors like Michael Redgrave and Emlyn Williams who have written intelligently about the actor and theatre, as have actresses like Fanny Kemble, but none wrote of critics. It was Miss Kemble's uncle, John Kemble, who spoke for all performers in relation to the breed when he said, 'Damn these fellows, they will have their way; in fact, I would sooner they cut me up all to pieces than not notice me at all.' It all comes back to ego in the end, but is it the necessary ego of the working artist who is impelled to pursue his vision, or is it the ego of the particular person who 'houses' this artistic talent and sells it off in large or small chunks for a living? This is a vital dichotomy and it must be understood when considering the actor's reaction to criticism.

Shostakovich wrote a whole symphony as a response to 'just criticism' but actors are not encouraged to write to their critics, even to thank them. It might compromise both parties at a later date. If a painter paints a picture, art critics discuss the result of his efforts, not the man himself. When a composer offers a piece of music it is examined bar by bar but the composer himself is not usually subjected to the same minute scrutiny. The actor, however, *is* his own artefact, and what he does on stage is dealt with as the personal revelation of the human being behind the act. If he acts badly, in the opinion of the critic, then it is implied that it is the man who is deficient, not the actor. This can often be unduly wounding to the self-esteem of the performer.

When one's faults are plastered over so many column inches it's hard to preserve some dignity when ordering a beer at the pub at lunchtime or out shopping next day or sitting in the hairdresser's knowing that the next snip of the scissors might bring up a reference to the night before. If not, it's bound to come up at some time in some conversation somewhere. People can't wait to feel superior. Few other professions spill so much over into the professional's private life as does the actor's. Even when the actor gets a rave review, people are shy about mentioning it.

It's all too personal somehow, they don't know how to treat lavish praise of another, whereas it's always easier to sympathise. They don't realise that when an actor gets a good review, to the performer it's like getting a big tick from the quality control manager in any factory or a thumbs up from the foreman for a job well done. The actor is not necessarily the better person for it, but he certainly feels the better actor.

The tall poppy is not the actor's favourite flower. Why can't the meed of praise be enjoyed when it does come, if only to compensate for the kicks up the backside previously received? The best review any actor can hope for is a flattering comment from a fellow-actor, yet why is it the most vociferous comments always come from people who know little about what the actor was trying to do, or how difficult it can be at times to do it? But then everyone considers themselves drama critics, just as Charles Macklin said years ago. Macklin was a famous 18th century Shylock, and teacher of drama, who noted that, 'all people judge of acting for the pleasure they receive from the actor… but without entering into the science or art of acting.' He was right, although it must be said that it isn't easy to be objective about a process so subjective in its realisation. The actor's own instincts and experience are the best guide to the exterior show on which these interior insights rest. Otherwise, the performance might as well be judged on the costume worn.

The uninformed critical response is often reflex and is arrived at because of so many variable elements such as the conditions in which the performance is given and the state of mind the spectator is in at the time. But does anyone ever give a thought to the state of mind the actor is in at the time? Good critics do. They know that there are no absolute rules, no given formula, it is all as it happens, and the critic's task is to catch the moment as it flies. The critique may quibble about points here and there, but if a point of distinction can be made, a subtlety noted, a nicety of effect commented on, the thanks of the actor will be earned.

The critic is not there to analyse the work like a scholar or hack it to bits like a butcher, but merely to comment. The critic's first duty is to make public the fact that the play is on at a certain place at a certain time. Everything else is extra to this basic intention. That it may make for good reading, and also may instruct or raise a laugh is an added bonus. The notice of a play in the theatre is first and last a news story.

For the actor, it is only slightly less than a matter of life and death.

A good notice for one night's playing might set up work for the rest of the year, just as a bad review might see the unfortunate thespian queuing up at the nearest Job Centre before long. This very volatility goes with the job. Everyone knows it and has to live with it. Which is why actors get up early next day to get the paper and have to read it standing there on the pavement outside the newsagents with people hurrying by on either side. How can they be so oblivious of the importance of this small column in the middle pages? If it's good personally, sod the play, a loud 'YES' or 'YIPPEE' is let out and everybody stares. If it's not good personally but excellent for the play, something unprintable is whispered and the milk being carried curdles in its plastic container. It is a long day ahead after that and it's hard to go into the theatre that night, but it has to be done despite any personal disappointment. It's only a matter of pride, actor's pride. But it's the same actor's pride that will make any actor go on, no matter what has been written.

Yet it's hard. To have done all that work and then not even a mention. It is as if his part in the play had never existed. Not exactly an uplifting feeling. Strangely the actor seldom feels jealous of a colleague's success in the same production. The work itself makes its own bond. The actor only gloats or weeps in private. Personal vanity has a practical connotation for the actor. The same milk and newspaper have to be bought next morning and the morning after that, and the rest of the real life has to be dealt as it happens. Never believe actors when they say they never read their notices. They may well not read them while they are in the run of the play, that may be very sensible, but you can be sure they'll have a wee peep at them at some time, even if it's only in the material sent from the cuttings agency.

Should the critic lapse, any faults in copy are dealt with in the secrecy of the editor's office, but for actors, their supposed omissions are writ large for everyone's gaze the next morning or the next Sunday in the heavies. This is why it is hard for the actor not to take the critic seriously. The rest of the run could hang on a syllable, and next year's contract work could depend on the critic's turn of phrase. This is not always easy to take, especially as the critic's copy has to accommodate the sub-editor in matters of space on the page and the best copy might have to yield to the latest bimbo 'sell'-ebrity's divorce after three days of marriage.

The last paragraph of a review can be lopped off because an advertiser

decided to double the size of his ad. From such small decisions are lives shaped. Who knows who might have read the omitted section of the notice and made another decision? Scholars call this the Gaia Theory, where the smallest event can cause irrevocable change. Actors call it bloody bad luck if you got a good notice in the cut version, but then again, it would be good luck if the same actor were 'panned' and it wasn't printed.

Reaction then, is not ego, far from it. It is a cry for reassurance from a very vulnerable specialist who practises an evanescent art by night and who has regularly watched meticulously prepared best efforts float into the air above the heads of the gathered spectators. Success or failure here will only be known the next day when he reads about it. Yet the actor knows more than anyone how it has gone. The audience gives its answer at the very moment of action, but all doubts have to be dispelled or hopes confirmed. Which is why an early newspaper is bought, or the Internet checked.

The review of the performance, whether in a newspaper, magazine or even on the Internet, is the only tangible proof the actor will have that it ever happened. Yes, fan letters might be received, or kindly old ladies will smile in recognition, but it's the unyielding permanence of newsprint in the light of day that announces that it really happened on that night and the actor was a part of it. This is why actors have scrapbooks. It is far from being a testimony to their conceit, rather it is a record of survival, a tribute to attainment in a difficult field. Of course, it provokes memories, but they tend to fade – or distort. The triumphs become vast affairs, but so do the failures and it is a matter of deep psychology that the journeyman actor can barely remember the good notices he has had but the bad ones are ingrained in the mind indelibly. What Kipling called 'these two great imposters, Triumph and Disaster' have been faced too often to worry for long about either. Dorothy Parker showed her sympathy with the actors when she wrote in a review,

'The only thing I didn't like about *The Barretts of Wimpole Street* was the play.'

Groucho Marx was even more trenchant,

'I didn't like the play but then I saw it under adverse conditions – the curtain was up.'

And Orson Welles is reputed to have added,

> 'Every actor in his heart believes everything bad that's printed about him.'

Perhaps the most famous review of all was written by Eugene Field, an American critic, who wrote in the Denver *Tribune* of one actor's Lear in 1880, 'He played the king as though under the momentary apprehension that someone else was about to play the ace.' Finally, in this sequence of critical one-liners is the wailed response of one young lady in the audience as she watched a provincial Hamlet utter his last line, 'The rest is...'. He never finished it because the female voice cried out, 'Oh don't die!' There could be no higher praise.

The actors' is always a child's hope set against a mature adult's experience, and this is the actors' anchor. Theirs is the most impracticable, impossible job in the world but no actor would change it for a stock-broker's profits or civil servant's security, because every follower of Thespis knows that, all in all, whatever anyone says or writes, it's a wonderful life. Only the actor is privy to the secret joy when the rehearsal drill is transformed into a performance dance before an audience. All the per-former wants is to keep on dancing, to grow old to the sound of theatre's siren voice. Meantime, the dry scrapbook record is there and open at a page which shows a young person with shining eyes ready for anything, on another, the same person with the first lines under the same eyes, and on yet another, the eyes are behind spectacles. Only the actor knows that the same human being is common to all three faces.

It is an irony that even the greatest rave takes its place in the end with the most violent panning as a piece of paper that can crumble in the hand, and the actor also knows that however much his species may be accused of being no more than an ambulant monument to exhibition-ism, there has never been a statue erected to a critic. Besides, there are other marks of notice. Theatre ranks are regularly swollen with Peerages, Knighthoods, Orders of this and that, and nowadays, University Doctorates are the new accolades. Even drama colleges are happy to accept actors' papers as archive and a field of legitimate research. This is at least a better alternative to the apocryphal fish and chip shop. It's good to know that a higher degree may yet be obtained from a moun-tain of yellowing bits of paper, book-bound or in plastic envelopes,

gathered from the first overconfident steps on a stage to the last wary appearances ready for anything, and now put to good use by helping educate a young person who might not have been born when the scrapbook was begun. Thus is altruism forced upon the self-obsessed, even if it is only evident in the words of journalist critics.

Naturally, the actor grows older and retreats more and more from the scene. Nevertheless, the grease paint has left its mark, because, figuratively speaking, it is deeply ingrained. Ageing is inevitable and can't be avoided but perhaps it is less a retreat than an advance towards the compensations that age brings. A new reality presents itself which is based less on pretence and more on actuality. Relationships can become more relaxed instead of rehearsed exchanges performed to impress or to elicit favourable remarks from critics. Even greasepaint can be washed off from the face, given time, but it's harder to wipe from the soul.

As for critics? All actors cling to what an American President, Theodore Roosevelt, once wrote of them,

> *It is not the critic that counts. Not the man who points out where the strong man has stumbled or where the doer of deeds could have done better. The credit belongs to the man who is in the arena; whose face is marred by dust and sweat and blood; who strives valiantly; and comes short again and again, yet who knows the great enthusiasm; who, at the best, knows the triumph of high achievement; and, who, at the worst, if he fails, fails while daring greatly; so that his place shall never be with those cold and timid souls who know neither victory nor defeat.*

Dealing with Fame

HISTORICAL ASIDE

1783: John Philip Kemble, first son of a strolling actor manager, and brother to actress Sarah Siddons, abandons his studies for the priesthood to appear as a statuesque Hamlet at Drury Lane Theatre, a stately start to a long and improving career as an actor. 1809: Drury Lane Theatre burns down. The Kembles became a theatrical dynasty, the best-known being Fanny Kemble, who was Ophelia to Edmund Kean's Hamlet in 1812. Kean was a foundling, reputed to be a natural child of the Earl of Halifax. He was put on stage as an infant and went on to become one of the greatest actors of his time, despite being as fond of the dram as he was of the drama. His wild, amoral ways alienated playgoers. He was only 43 when he finally collapsed and died while playing Othello with his son in the cast in 1833.

FAME IS NOT, nor should it be, an aim in itself. It's a consequence of being known for what you do and for doing it well. Its attainment is usually a gradual process keeping pace with the actor's own stage-by-stage development but it has been known to come at a jump to many. However, when one checks any supposed overnight sensation a background story of hard hack is generally found. It takes time to know how to take that big chance. The prodigals who emerge too early don't always last a lifetime, because not enough work has been done at the base. It's the sound foundation that supports a high rise, not the pretty decoration on top.

One career disadvantage to the actor is that it's not always easy to plan ahead. Things change as often as minds, productions come and go without even reaching the first read-through. The actor is rarely on firm ground in the course of his career. When a new project is mentioned, it is a mirage until the contract falls through the letter-box. Then the long run being relied on to pay the school fees or renew the washing machine

withers under the critical lash, and it's back to square one. It is time to start all over again in the soft-shoe shuffle from interview to interview like the steps of an old familiar dance. The intellect tells the actor these times that acting is a stupid occupation that doesn't always make sense, but intuition suggests otherwise. As Leibniz says, 'There is nothing in the intellect that was not first in the senses – except the intellect itself.'

The heart is at the centre of all things, which is why the heart is the biggest support the actor has. It has to be in whatever is attempted. 'Are we down-hearted?' may be the question and the answer is 'Yes, often', but in the theatre it only happens when the particular performer has been fed a little nibble of fame, just enough to allow a small trade on the stage name, such as it is. An actor is first known among his peers before going 'public' as it were, and it nearly always comes as a pleasant surprise to the emerging actor when recognised outside the rehearsal room.

It is always the same line from the passer-by, or at least along the same lines – 'Don't I know you from somewhere?' They screw up their eyes as they lean in towards the poor actor's face, who shies back not knowing how to react. The questioners are almost angry about not knowing a name to put to the face and walk away with a sad shaking of heads. They probably have had a quick glimpse of the same actor's face on a television screen but what causes them concern deep down is that this actor has been *in their homes* and they feel they have owning rights somehow.

It's a different matter when the actor is recognised by a theatregoer. The difference is that the theatregoer has been a visitor to the actor's home, the theatre, and is usually recognised by the character he played. 'Weren't you Lorenzo the other night?' or 'Oh, you were a lovely Jessica,' to the actress. There is no question which street greeting actors prefer.

Most actors know the perennial question that haunts all known faces – 'Excuse me, are you…?' People don't realise what a searching question that really is. It can't really be answered by a smile and a nod, and a reach for the pen. There are times when the actor is uncertain. Even worse is 'Sorry, did you used to be – ?' It is rarely plain sailing, an actor's life. It is either peaks or troughs, feast or famine, public acclaim or total anonymity. It is difficult straining for recognition on one hand yet at the same time striving to maintain a normal ordinariness in the other. But given an intelligent partner and unimpressionable, strong-minded children plus some good, untheatrical friends a balance somehow works itself

out. A *modus vivendi* is found that allows the actor to be Dr Jekyll at home while Mr or Mrs Hyde is confined to the dressing-room.

Actors see their agents grow fat, their accountant prospers, even the men who tend the garden or clean the windows appear to grow richer, yet still the actor chases the whirlwind along the yellow brick road, armed only with little bits of paper that confirm that the person named can actually do the job each Equity card says is theirs. Sadly, no actor is equal to their own billing and over the years they watch these same bits of paper turn from white to yellow then to a depressing tan colour in the scrapbooks, but resolutely they maintain the same smiling face to the sun.

Dealing with fame with tact and modesty is a skill that has to be learned and not everyone manages it. Some of the best actors did so by being genuinely surprised that people should want their signature on a piece of paper. These are genuinely modest beings. They are few but they do exist. They simply regard themselves as merely being lucky in working with the right people at the right time, and that their careers were made for them by other people, disclaiming all personal talent.

This is patently untrue but it is true that any career depends, not only other people, but a great deal of luck. I think a degree of good fortune is needed in any walk of life, but every actor has a sackful of luck stories, most of them of bad luck, because it's always more interesting. Yet it is a fact that one benefits from being in the right place at the right time.

A chance meeting can lead to the first job, which leads to other jobs which buy the first house, attract the first agent, who then wins the actor a film contract, which offers the first taste of real money and the first sniff of success. There are a lot of firsts at the beginning. Luck does apply but, as has been often said the harder one works, the luckier one gets. However, few actors make the mistake of thinking that it might go on forever. This is a young person's error, and no one ages more quickly than aspiring actors. Maturity is thrust upon them as they inch their way through a very crowded marketplace.

The theatrical career might be likened to a journey on the elevator going up. At the start there are several options, and they are available to you on a panel at eye level. This gives you the number of the floor above and a name beside it. You press the floor required and you immediately ascend towards it. In the theatre elevator the levels might read: 1) Stage training, 2) Preliminary experience, 3) Extended experience in other media,

4) Notice and peer appreciation, 5) Fame and Success, 6) Top Floor, Status and Posterity. It would be wise to go to the top a level at a time, but it is astonishing how many press Button No 5 for 'Fame and Success' without thinking, not realising that even if the elevator went there as instructed and the door opened to fame, there is no way they could go on to a worthy posterity with such a limited background. In which case, the only way left is down. Step by step, floor by floor, stage by stage is the only sure way up, yet some actors are convinced they ought to have done it in a bound.

The psyche of the average actor defies definition. Pushed and pulled so many ways simultaneously it's a wonder the poor player knows where he's pointing at any one time. Lifted up only to be cast down, and when at their lowest, that's when actors are yanked to their feet again by the promise of a new start. Suddenly raised up again, the effect can be dizzy-making, but a good grip has to be taken of any new opportunity. The actor is a child in ancient guise, who is given the secret of immortality but can't always remember where he put it. Which is why he continues to search. He had it a few productions ago, so it must be somewhere about. Then, quite suddenly, it will pop out at a most unexpected moment one night, and both colleagues and audience alike are astounded. He goes home wondering how it had happened, and would he be able to do it again tomorrow night? He can't wait to get to the theatre to find out.

Actors don't get famous worrying about things like this. It's the end result that matters. Audiences are not interested in the machinery or the engine, only in the fact that whatever is offered to them works. Some degree of inspiration is called for, but inspiration doesn't come at a press of a button. It has to be worked for, or at least the ground must be prepared, so that if things are to grow the soil is ready. This is the actor as geologist, digging away, not knowing exactly what is being looked for, but hoping it will make itself known right away. Meantime, the digging goes on. This is a long way away from celebrity.

Celebrity sometimes comes by default. This is catapult fame, which springs back as readily. The nine-day wonder is a small fame really. The larger aura belongs to the artist/actor who has worked hard and long at his or her craft and, in so doing, has won the loyalty, not to say the love, of audiences. There is nothing crafty in this. It is only that they have

learned to expect a certain standard from such an actor, and not necessarily a leading actor either. Occasionally the great film star can condescend to step down from the screen and appear in the flesh in a play, but in so doing the balance of casting is altered. Of course, the 'star' will get the usual mandatory applause on entering but is such an entrance made as the great star or as the character in the production? It is not the actor's fault, it is the problem of being a 'name'. Its weight often obscures the worth of the actor who has to carry it. First rate actors by any standards often find it difficult to be accepted as someone else on stage when the audience only wants to see in the flesh the larger-than-life image they know from the cinema or television. This is a pity because a good actor is a good actor in whatever medium.

The face of the actor as far as the public is concerned is that image contained within the bubble of fame, and when the bubble bursts, as it always does, it is the image that fades, the actor remains and will go on working. As the years go by, the leading role dwindles to the cameo, but that is inevitable. The star's main attraction now for audiences draws more on nostalgia, than direct, contemporary appeal, but it suits older legs and a lesser capacity to remember lines. All physical attributes naturally deteriorate, but what is sad is when the actor clings to a former fame as if it were a shield. Decreasing powers are hidden behind it, and the same 'name' holds it up as a prop instead of a label. If the actor can't eat his notices, he can't live off a famous name. Too many great careers have dribbled to an inconsequential end, dying a slow death because the actor has elected to go that one mile too far, fatally wounded by his own vanity. Audiences are by then indifferent. The actor will talk of 'my public' but it is they who own him just as the horde in Roman arenas owned the gladiator. Audience thumbs are just as quick to go down as up, even today.

If the beginner actor is prompted only by a desire for fame, he will not get very far. He will be chasing a chimera, an illusion, and that is hardly the ambition of a serious performer. Make no mistake about it, acting is a serious business and requires as much study and close attention as any other artistic discipline. The trouble is, the better it is done, the easier it looks and this confuses people into thinking anyone can do it. It is hard to imagine the amount of rehearsal that goes into the simple business of rising from a chair on one line and sitting on another, picking up a drink on the way.

This is something people do every day in their homes without thinking about it, but try doing it saying hurriedly learned words that have been put into your head by someone else, to someone who is pretending to listen and both of you are doing so before a crowd sitting in the dark watching. Only then do you realize that you're walking awkwardly on the deep pile of a carpet towards a chair that is too low. This is professional acting and not all the publicity in the world will help you do it any better.

One auxiliary of stage fame is the social caste it gives the actor. The vagabond has come a long way in a couple of thousand years and is now on the social list with a capital A. It's a big jump through the social hoops to land up in the centre of the ring. However, it is found that what is applied on stage, is, in fact, a concentrated life lesson in manners and fashion. Being invited as a guest at famous tables carries with it the sense of being hired for the 'performance' the actor may give despite himself.

Famous Victorian and Edwardian actors used to make a practice of such social appearances and they certainly didn't come for free. Although in those days they had to come in by the tradesman's entrance. One very famous actor of that age was so incensed about being sent round to the back door that he demanded his fee in the kitchen. It was duly given him in guineas. He then proceeded to entertain the butler, the cook and the maids with a short recital before walking upstairs, through the sitting-room and out through the front door where his carriage awaited. It might be said to be the first 'kitchen sink' performance but few actors have that sort of bravado. Most will tolerate much for the sake of a good fee. This is the prostitute aspect of the job that people tend not to think about, but the actor is a tart at heart. He sells his physical skills for money, and must make no bones about it. The difference is that there is within his practice an aesthetic and spiritual element that may be denied the whore, but who is to say that catharsis is not available in the bordello? The unholy trade embraces all kinds...

In the end, the best way to deal with fame is to ignore it. To learn to see it as a mist that has built up gradually and obscured your view of reality. It is a belt of hot air that is built around a person and insulates him or her from the rest of life as it's actually lived. For a time, the actor with fame, whether it's local, regional, national or global, thinks he might really be important, and that all the perquisites that come his way

– not only the best tables, but the complimentary meals, the free seats, being whisked out of the queue before the football match and plonked in the directors' box – all these things are his by right. But they are as much of a pretence as his job is. The only difference is that his job-pretence must be taken seriously.

If fame is indeed a spur, it is best applied to a thoroughbred. Training will out in the end and the race isn't always won by the favourite. The fame game is a young person's pursuit and it should be left to them to play it with eagerness and zest. Let them kick the bubble around until it bursts. Meantime, the mature actor can enjoy being ex-famous as long as he doesn't resent it or resist it, and is able to laugh at its nonsense. There comes a stage when he is free at last of the trivial, the superficial and the vain even though he meets all of these at the fashionable dinner-table. As one gushing hostess once remarked, 'Actors are so interesting aren't they? One never knows what they're going to say.'

'That only applies on stage, ma'am,' one established actor told her. Recognition would be immediate had it been achieved on television where fame is switched on with the remote, but then it's just as easily switched off. Stage fame is candle-lit by comparison. It is less bright but lasts longer, and even if it flickers from time to time, there is less chance of getting fingers burnt. Once lit, it seldom goes out, unless he blows it out himself. A smoking candle is a good image of the actor in the end. In that wisp is a glimpse of the evanescent moment, gone up in smoke maybe, but the memory of the moment within it is lasting.

Typecasting

HISTORICAL ASIDE

With the rebuilding and enlargement of the two main theatres, Covent Garden and Drury Lane, at the turn of the 19th century acting styles changed to accommodate their size and acting standards suffered accordingly. Spectacle and machine effects became the norm. The actor's role was relegated to that of commentator on the action as the art of the drama declined. Plays were written by non-theatre poets and novelists, like Joanna Baillie, to be read rather than acted, and their content showed no sense of theatre's technical demands. Wordsworth, Coleridge, Keats and Shelley all dabbled in the drama and only Shelley's 'The Cenci' (1819) was playable. Literary theatre was simply not theatre and even stage work by Byron and Browning couldn't disguise that this epoch in theatre history was sadly barren.

A RARELY DISCUSSED BONUS of being in the acting business is in the continued education the profession offers. Depending on the play being done at the time, the actor can be working every night in a forester's cottage, a ducal castle, a smart apartment or a dingy boarding house. With all these settings, go the different social mores that attend to each. The actor takes this in. The script gives the information on each type of character shown and as the lines are learned, so too is the history of the times in which the character lived. This tells the actor how to behave on stage, which fork to lift, and how to deal with the props given. The background research required before embarking on a role is like taking a paper in an exam. Each play is a seminar in itself. And this is all before he has said a serious word in rehearsal.

And how it is said also matters. Every kind of provincial accent known has been ironed out on the road. Received pronunciation is not the norm it was but Cockneys have become old Etonians and even the adamant Scots burr has been softened behind the proscenium arch. Only

Irish holds out against change, but then the soft, charming Hibernian lilt lends itself easily to the pretender that is every working actor. For actors, the theatre is not only their workplace or playground, it is also their university. Through it, the best of art is made known, the finest music becomes familiar and most of the great literature is available in the course of a career.

Every exposure to an audience is virtually a test-paper on psychology. The bulk of general knowledge built up while working is useful for more than crosswords, it applies to every kind of social occasion and allows the actor to sit with the high and the mighty and hold his own with either. He knows they're acting their parts almost as much as he is – and not always to type either.

When a dramatist writes a play for the theatre it is as if a large bank draft is drawn out and complete reliance is put on the cast of actors to cash it in front of a paying audience. It is a huge act of trust on the part of playwrights. Sitting in the safety of their studies they fill the page with figures from their imagination and hope that the producer or director will eventually realise these 'pen' people in terms of flesh and blood performers. The onus then passes to the casting director, if one is used, who will select from the long line of hopefuls passing before his or her desk, those most likely to fit the description given of the characters in the script.

In the first instance, this is an entirely physical choice. If a large man is required, then it's the big men who are auditioned. Hair and colouring, even baldness, can be adjusted with wigs and make-up, and height with high heels, but a thin man has to be thin even if a fat man can be arrived at with cushions. Having dealt with the body bits it then comes down to the personality angle. Assuming that the given actor can act, then it is also assumed that he can play almost anything. This is not so. The individual element that is in all human beings is never more evident than when a series of similar body-shapes try out for the same part in a play. They read the same lines from the same play in the same place and yet it is extraordinary how different and how varied each reading can be. It is not that one is superior to the other but that they are decidedly not all the same.

This story may be apocryphal. It appears that a particular actor was a regular at all the London auditions. He had few rivals in the strangulation of Shakespeare on a bare stage at some cold, unearthly morning

hour. Most auditioners found him laughable and fellow actors referred to him cheerfully as 'McGonagall'. He earned his living as a full-time understudy of mid-level parts but had never been known to go on for anybody. Being around dressing-rooms all the time, he heard about all the auditions going on in the West End, so there he was, at audition after audition, trotting out the required piece with aplomb, if not with much sense, and appearing to enjoy himself immensely. Imagine the surprise, therefore, when, after one excruciating reading, the director's voice was heard from the torchlit table in the stalls,

'Thank you, Mr – er. That was – interesting. Ye-s. Would you be kind enough to come down?'

The other auditioning actors in the wings could hardly believe it. He had been so dreadful. Being called down generally means that you had got the part but the poor man was still standing trembling at centre-stage. The director's voice again boomed out from the stalls.

'Mr So-and-So, we would like to offer you the part.'

The poor actor couldn't say a word, so the stage manger walked out to him,

'They want you down on the stalls, sir.'

'I can't,' the actor blurted out.

'Why not?'

The reply came in a plaintive wail,

'I only do auditions.'

And he ran in a panic into the wings.

On the other hand, one has also heard of the promising careers cut short at the end of the audition by the simple utterance of that baleful, four-letter word – 'NEXT'.

A blazing talent will set fire to any text of course, but, in the same way, a quirky reading or an unexpected tone will add interest to the speech and alert the ear, or ears, of those auditioners in the dark of the stalls. It is up to these listeners to determine the effectiveness of each auditonee, and to balance one against the other in terms of the overall casting of the final ensemble. In the end, it has to be a team effort, not a series of one-man-shows, so it is a delicate process. It is made even more so by the fact that the actor is never more vulnerable than at this stage of job-hunting. The nerves will never be as bad again until the first night, that is, if the job is offered.

It all depends on whether the actor is the type they happen to be looking for. It's all right for the already famous, because even the dramatist will tell the producer that the lead is a 'So-and-So' kind of role and the leading lady would suit 'Such-and-Such' or 'You-Know-Who'. Even the main supporting roles hint at well-known names in the trade but for all the rest it is crumbs-from-the-table time and the scramble is on. Word goes round in the actors' pubs (the clubs are for those and such as those) and soon actors are looking in the mirror at home wondering how they can distort that same old face once again to fit what he hears they're looking for.

It's demeaning and often dehumanising to submit to this Op Shop of the dramatic art but there is no other way for the poor player to sell his and her wares other than by putting themselves on show like this. Their names are put forward by their agent and they await their call. When it comes, it's always seems to be at an inconvenient time.

Never mind, half-a-dozen phone calls later, with things re-arranged, the auditionee arrives late because of the traffic, rushes on stage, despite the glare of the stage manager in the wings, takes a deep breath, and lets go. It's never as good as it was last night in the bath, or in the kitchen that morning as the appropriate partner listened for the umpteenth time but at least all the words were there. This pre-audition panic is worse when there are children around. They try not to hear, being embarrassed at seeing their own father or mother standing against the pantry door, speaking in a funny voice and pretending to cry. However, despite this less than encouraging sending off, the audition is a success and the part is won. The same frowning children will all get a little present that night. The partner will only heave a sigh of relief. That's next month's mortgage safe.

For the actor it's yet another beginning, and there is no more exciting time. It's another part, another challenge and work is got down to with a will. There are old friends to meet again and new ones to make, and the first rehearsal day can't come quickly enough. As the reader has already gathered, there is no closer body than actors beginning a new play. Soldiers meeting before a battle might have the same sense of unity, except that soldiers take it less seriously. They have to, they couldn't face it other-wise. Actors, too, believe they might 'die' but only in the theatrical sense, and even if they do, they know they will live to fight another night.

Meantime, it's off again in search of a character. Each actor is on a

private mission here, and applies himself assiduously to the task. Every stone on the way is examined, every leaf on every tree is inspected as the burrowing begins among the forest of words in order to find the right path. Unfortunately, there are as many different approaches as there are actors. Some go immediately for the externals. Suddenly, a limp will emerge or a stutter is heard or one is already wearing the oversized coat thought essential to the playing. In truth, these are just crutches to help advance progress. As rehearsals go on, it's noticed how much 'business' is dropped and how many props are thrown away as the actor gets nearer and nearer the centre truth of his part.

It's an arduous time. The gossip, the laughter and the in-jokes get less as the first run-through draws near. The books are down and the director is more and more tight-lipped. This is when the actor in demand wonders whether he ought to have taken that other offer. There is no pleasing the performer at this critical stage when exactly halfway between the first reading and the first night. This is when the partner needs to be understanding and the children quiet. Somehow, by the daily rite of rehearsal the actor gets nearer and nearer the idea that was in mind at the beginning. It's always the same process, you read the part on the page, you 'see' the character at once and then you spend a month or more losing it and finding it again. The day you do is exhilarating, and all the sweat is lost in the tears of joy and relief, and, if you are young enough, you can't wait for the opening.

The actor knows he only got the part because he was the nearest to the type they wanted, but he also knows he has made it his own by plain, hard work. He can't be expected to be exactly as the playwright originally saw the character, but given the interpreter-director's help, or sometimes, which is even better, being blessedly left alone by him, he has arrived at a kind of family likeness to the part that the playwright will recognise. It is perhaps a good thing that Shakespeare isn't around to see what some actors do to his creations, but then, the great classical parts are actor-proof. The opportunities offered to a Hamlet, a Macbeth or a Lear are so good that if the actor says the lines intelligently and coherently, he will get by.

It's the smaller parts that are the traps. Notice that 'traps' is an anagram of 'parts'. This is telling, because it is the small part that finds out the small actor. The lesser actor will always try to do too much. He is

like a flailing semaphore on a tiny atoll in the middle of a vast sea. It is a tiny action, but it can be irritating as it goes on, because there are no small parts in a play, only small actors. Better actors, on the other hand, are marked by their economy. They show restraint and will not move a muscle unless it serves the part and the play. This is called technique and calls on a long experience. It takes years to learn to stand absolutely still on a stage. Every little unneeded move made is really a call for help, hence the semaphore from the uncertain. It is a fact that it is always the lesser actor who forgets to remove a wristwatch in a period piece or goes on with a wedding ring gleaming. The good actor takes care of such things just because he *cares*.

And because they do, actors enjoy opening in a new play and soon settle down to the comfortable rhythm determined by the play time shared on stage with friends and all those other friends the audience become in the course of the night. Actors in a long run enjoy the smaller things in the production, like getting that laugh in Act One, checking the off-stage clock so that the tag line to Act Two is delivered at five past nine exactly and that the big exit in Act Three gets a round of applause. These are minor professional rewards that don't always happen so they are savoured when they do.

The regular salary is also enjoyed for a while and all actors quickly get used to it. The ghost walked every Friday and he was there with his hand out. The ghost was reputed to be the figure of an actor who haunted the circle looking for the manager who ran off with the takings at the interval, which is why actors, until quite recently, were still paid at the first interval, but today cheques go off to their agents each week, or, if you are the star, at the end of the run to an off-shore island by direct debit on the Net. It matters little, they are all tributaries feeding off the one big river that just keeps rolling along.

There are so many rites and superstitions in the acting business that sometimes it is hard to know what to say or do backstage. One of the older actors is heard telling a younger colleague that they mustn't even mention *Macbeth*, or 'The Scottish Play' as it is called backstage. This was because, as Shakespeare's shortest play, it was always put on when the present play was about to be taken off prematurely due to poor audiences or notices or both. So, if one actor heard another muttering *Macbeth* into the mirror, it was obvious one of them would be out of

work soon. Nor was anyone allowed to whistle backstage, because that's how the sceneshifters signalled to each other in the dark during scene-changes and you might bring a large wood-and-canvas flat down on your head. Also green must never be worn in a costume because that was the colour of the old stage cloths and you would never be seen against it. And so on and so on.

Actors like sailors, or sports people or any other workers in risky trades, tend to be superstitious. Every actor has his or her own particular buttress against the strain and it may take any form or manner. So much of their living depends on chance that he takes no chances. It is my calling, rite or wrong, as they might say.

After the show opens the notices determine the climate backstage for a while but if they are not too bad everybody settles into the little village that backstage becomes for the duration of the run. Routine now takes the place of tension and uncertainty and everyone settles down to his or her place in things. Those who were favoured by the press hug the feeling close to their chests to keep it warm for as long as they can, those who were not so lucky try to forget it by concentrating on the next job in the offing. Unfortunately, some actors believe their own publicity and turn their own lives upside down to accommodate the publicist's hyperbole, but what is nearly as bad is that the public believes the actor's casting is the real man. If he plays a drug addict well, people think he is a drug addict, if he does a good drunk, then he *is* a drunk, and so on.

It is hard to escape from a good characterisation, which is why the phenomenon of type-casting has developed. This is where the actor who plays a good butler goes on playing a long line of butlers for the rest of his life, or the little runt of an actor who is good at small-time criminals doesn't get any bigger as he goes on, but he never starves. The actress who plays a brilliant tart early in her career finds it hard to get off the street and some have made a whole career out of being the neighbour next door. It is not the actor who is the little weasel, he merely plays him, but after a time the edges become blurred and he's a weasel whether he likes it or not. This is a shame and it leads to many fine actors being trapped in their first success for the rest of their working lives.

Many actors feel similarly trapped when in a long run. To some, such a relentless, long-term prospect is penitentiary acting. They would feel as if they had been confined to the cell of a particular character for

the rest of their natural lives and would prefer a quick death by critical abuse. The nearest thing in theatre to a life sentence would be the run that *The Mousetrap* (appropriately titled) had in London, but fortunately for actors' sanity, the cast changes are rung frequently to keep the production fresh. In any case, the actors would simply become too old to play their original characters. They may be richer at the bank but by confining their talent to a rut for so long they would be a lot poorer in other ways. There are roses to smell.

It is not a question of repeating the same lines and moves at every performance. It's never quite the same because the audience is never the same from night to night. In its capacity as co-performer, it has its part to play, and its effect is to cause the actor to vary the performance even if only to a miniscule degree. It may not seem much, but this nightly challenge by the new audience is enough to keep the whole cast on their toes. No, there is no chore in playing every night to an audience, because, in effect, to the new audience, it is a new play.

But it must be said, the routine surrounding a long run in the theatre can be numbing. It's the knowledge that the actor is chained to the stage door and every hour of the day leads inexorably towards that time when it opens and it has to be gone through. It is impossible to enjoy a cinema matinee because of keeping an eye on the time, and there are just so many doors and windows you can paint during the day. Often it is a real bore getting to the dressing room, and getting into costume, then sitting down at the familiar mirror and staring into it. Thank God, greasepaint works its usual magic, and it is almost with relief that you hear your cue, and you're 'on'. And the night flies by. At the supper afterwards, actors love going over the happenings of that particular performance. The last thing they think about is that it will be same again tomorrow night

Being type-cast is not the worst thing that can happen to the actor. Many people in ordinary life are type-cast whether they like it or not. Many sons are forced to follow fathers into boring jobs, many daughters have to nurse their own mothers all their lives. Single mothers have it hard and unemployed young men are type-cast already into obscurity, so the actor can't complain. Actors are only playing at it.

Human nature has seen to it there are as many types available for impersonation as any one lifetime can hold. There are actors who can't keep their hands out of their pockets, others who can't keep theirs to

themselves, they must flutter and gesticulate like penguins. Some actors can't wear tights, and others will always carry their hats on stage for some reason. One well-known West End actor was so vain about his baldness that he wore a bald wig over his toupee on stage and would sprinkle salt on the shoulders of his expensive suit to simulate dandruff. Actors have to be alert to the foibles of their fellows because it's part of the performer's job to put all kinds of people up on stage with accuracy and verisimilitude.

It's not always necessary to fall in love with your co-star but it helps not to dislike him or her. This need is mutual. The audience enjoys that feeling of *frisson* that two likable people up on stage impart when they like each other. It is just as quick to sense when that *animus* is not present with the lovers on stage. This is when the long, lingering kiss gives way to a peck on the cheek and the fond embrace to what may only be described as a temporary collision. This is not only insulting to the audience, it is bad acting at the basic level. It is not at all necessary for the actor to feel the emotion he is required to convey. Indeed, the less felt the better, but it is vital that the audience feels what is intended by the actor. He must always bear in mind that he is there for their benefit, not them for his.

It must be said that the stage kiss must be the most boring piece of production business ever offered to an audience. Two figures fused into one are doubtless having a great time but a static position where nothing is seen of the actors' faces is boring for the spectator. They need to see faces, particularly eyes, to completely understand the action. The actor's eyes are the torchlight which illuminates the performance. The audience can't hear if it can't see.

Sex is at the root of everything and it certainly underlies most action that happens on stage, even when it is not the primary intention of the script. The appeal to the senses is the basis for all attempts at theatrical persuasion and the strongest sense of all is the physical appeal of the body. Not in nudity, but in the subtle implication of nudity as seen in the way a dress hangs or a shirt is laid open to the waist. Costume is important to the act, because it is the first signal of identity. We all recognise the difference between the university don and the dustman principally because of the clothes they wear. And if both wear the same suit, they would wear it in a different way, even if it's only how they tie their ties

at the collar or why one holds his hands in front of his body and the other behind his back. It is the actor's business to notice these things, for it's on the aggregate replication of such detail that he builds up a credible character. It's as if he sketches the outline and the audience puts in the light and shade, and when the actor gets it right, then between them they are able to give their mutual creation all the colours of the rainbow.

As a working actor, there is no feeling in the world like allowing the voice to drop to almost conversational level in the final scene of a show and know that the audience is following the sound all the way down the decibel ladder into that special area of reception where audiences go when given precise directions by the performance. Here be no monsters, but dreams and apparitions that beckon the beholder into enchantment. It is like talking to someone you love while holding their hands and looking into their eyes. There is no closer communication than when the actor becomes one with his audience and this fusion is the outward sign that they have grown into each other in a kind of happy marriage that feels at the end as if it had been one long honeymoon.

As an actor you want to reach out and hug everyone there. You can't do that so you put a cordon round them all and you pull them slowly and so gently up towards you and when have them in your hand, as they say, the lights go down for the play's end and the actor retreats. But there's a ghost of something left in the air. The spirit takes its time in leaving the body, the atmosphere needs time to dissipate. That is why, on good nights, audiences are almost reluctant to leave the theatre. On the not-so-good nights they are already on their way out before the tag line is spoken, but even then the actor has beaten them to it. He can tell a good show from a bad almost as soon as the audience, although it must be said, there are more good performances overall than bad. The audience sees to that.

Actors know that every audience shares the three great cardinal virtues – Faith, Hope and Charity. It has faith in the playwright that he will not insult them with a poor play, they hope that the director has cast well and has delivered a pleasing production, but, above all, they feel charitable towards the living breathing actor they see on stage. He is their plenipotentiary. He speaks to everyone there and for them. The audience doesn't see the playwright, the director, the designer, or the stage manager – only the actor. And the actor would have it no other way.

No matter how stormy the private lives of theatricals may be, at no time do they think to take any shelter other than that offered by theatre itself. Their every day leads inexorably towards evening and curtain-up. If it is true that actors work to live, it is also true that they live to work. Like everyone else born into the world, they learn to accept their lot, recognise their type and play as cast.

Have Script will Travel

HISTORICAL ASIDE

With the Industrial Revolution, and particularly the coming of steam railways, a new middle stratum of British provincial society emerges and these 'new-rich' citizens of the mid-19th century boss class demand appropriate dramatic fare. They have no interest in gods and goddesses or poetical allusions, they want what they know so naturalism arrives on stage with real tea cups and people smoking cigars. 1848: Dion Boucicault's 'London Assurance' shows the way. 1865: Tom Robertson's 'Society' follows, then 'Caste' in 1867 continues the trend. Henry Irving and Ellen Terry appear at the Lyceum to begin a new era. A dramatic revival is prompted by fresh winds from the north introducing the play of ideas from Norway (Ibsen), Sweden (Strindberg), Russia (Chekhov); and music-critic-turned-dramatist, George Bernard Shaw from Dublin, writes 'Widowers' Houses' (1892) to begin a long, formidable career as a dramatist.

WITH SO MANY INFLUENCES from so many minds from so many nations over so many centuries, the question arises, does nationality apply when the houselights go down? Are stage lights, in fact, international, and if so, is not then the acting tribe world-wide kin, belonging to no one race or ethnicity? Whether he is a Nordic or Zulu should make no difference to the actor with a line to say who seeks the best way to say it in public. By the same token, the *place* of the stage makes little difference. Recent Edinburgh Festivals are proof of that. 'Where two or three are gathered together...' appears to be the rule applied there. It need not even be a stage. In one case, even a telephone booth was pressed into service so that an Icelandic solo actor could give his performance to an audience of one. Body odour would be the only risk factor there.

All the actor needs is a point where the performance can be seen and heard by people gathered in a position to be able to hear and see. When the Royal Shakespeare Company was touring in Norfolk with the *The*

Merchant of Venice and Gorki's *The Lower Depths,* one patron buying a ticket was asked, '*Merchant* or *Lower Depths?*' She replied, 'I don't care where I sit as long as I can see.' Certainly, any production can be assisted by an imposing setting, use of light and sound, wonderful costumes and effective props, but stage dialogue is generally delivered a line at a time from one throat at a time to a listening set of ears and all that's really necessary is that the ears can hear and the eyes see.

Both sets of organs can be severely tested by the more experimental theatre presentations which appear to take place in every kind of space except a theatre. Off-Broadway patrons could be asked to climb a fire escape or scale down a rope to find the theatre at one time and nowadays, Off-Off Broadway customers might be handed a hammer and told to build their own. It seems there is no limit to excess in this absurd kind of theatre which puts an audience through a commando course before it is allowed to sit down. It's all very well to shake the audience out of its preconceptions, Every good director is all for that, but physical survival on the night should not be an issue.

Language, in whatever tongue, is always at the service of the act. One listens to a concert, but one sees a play. The actor's face can often tell us more than any dialogue can. Listening to a play performed in a foreign language can be completely acceptable, if well done. The Moscow Arts Theatre showed this when that company came to London, and even in Russian, almost every line of Chekhov's *The Cherry Orchard* came through by virtue of the company's acting strength in ensemble. It helped, admittedly, that most of the audience knew the play in English, but it was the power of the collective performances that held, proof that good theatre belongs in the flesh and blood of the actor at the given moment. It happens even as you watch and that is why we say we are 'held' by good acting. When it's good it captures you and when it's great it will not let you go.

The Comédie Française had the same effect on its tours beyond Paris, and Constant Coquelin and Sarah Bernhardt enjoyed great personal success in their world-wide appearances. In addition to the great Coquelin (a magnificent Cyrano de Bergerac), Madame Bernhardt toured the United States with a full company of actors, five servants, one secretary and 50 trunks of luggage. One could say she was well supported, but even so, it did not help her win over the Americans with her Hamlet, even

with Coquelin as the First Gravedigger. Admittedly, it was performed in French, which would not make it readily accessible in the Middle West.

However, where there is genuine quality and talent on stage, and a determination on the actors' part to communicate, language is no barrier. In nearly all cases, the audience, like Barkis, is willing. This is what allowed the early European strollers to move freely between Italy, France and Spain and let the George II, Duke of Saxe Meiningen, a royal theatre fanatic, take his famous Meininger company, an ensemble of players made up of royal estate workers and personally trained by him, to play no less than 38 cities in Europe, starting in Berlin in 1874 and coming to London in 1881.

His Royal Highness specialised in the management of crowd scenes. With the help of the German actor Ludwig Chronegk, the Duke divided his large cast of supernumeraries into groups under a leader and so was able to orchestrate a lot of bodies across the stage to great effect. Great care was also taken over costume detail and the disposition of three-dimensional scenery, which was novel for the time. Saxe-Meiningen was a moneyed amateur who, nonetheless, knew his theatre and spent his good fortune well. He was, like the English actor-manager, Charles Kean, among the first to realise the importance of the crowd in the mise-en-scène, and to give it a meaningful place in the play. The group became a personality in its own right, and every member of the crowd an actor in it. This was a considerable feat, to take a collection of unknowns, who were not even professional actors, and fuse them into a vital whole. André Antoine of the Théâtre Libre and Constantin Stanislavsky of the Moscow Arts Theatre were only two of many theatre innovators influenced by this company.

Eleanora Duse, the most famous Italian actress of her generation, spent most of her life touring. Called La Duse throughout her glittering career, she made a sensation in Victorian London. She was literally born into the theatre, being brought into the world in a railway carriage while her parents were travelling to an engagement with the family troupe in Milan. When she appeared in New York as Camille in 1893, a local critic made the good point that, 'Signora Duse does not attempt to make a Frenchwoman of Camille but fills her with the fire and passion of her own Italian temperament'. This is well taken, as it is always the self of the performer, under the cover provided by the role, which drives the characterisation from within.

Oddly enough Duse could not repeat her blazing triumph in Paris, perhaps because she was playing the part in Bernhardt's own theatre, who had herself played Camille not long before. There was a great rivalry between the two actresses but no enmity. Indeed, they appeared together in a gala tribute to Dumas, a performance that was seen by Bernard Shaw, who wrote,

> 'I should say without qualification that it is the best modern acting I have ever seen... Sarah Bernhardt has nothing but her own charm... Duse's own private charm has not yet been given to the public. She gives you the charm... but behind every stroke of it is a distinctly human idea.'

Very shy off-stage, and always reluctant to talk about her art, Duse, in a letter written in 1883, described her acting career trenchantly as a 'Way of the Cross we have all travelled; we have all talked about, but absolutely no one has defined it *completely*... It would be like explaining love.'

Signora Duse has hit it exactly. Acting is a declaration of love made by the actor to the audience, but it is a declaration caught in a web of words and the performer must work through this silken entanglement, in whatever the language, to make the text's intention clear. Which is why it often works better without words, when a look or a gesture or mere posture conveys the meaning immediately and if words are required, then an extra intensity can create the onomatopoeia or osmosis which does the trick. Mental attitude is all. Think right and it nearly always comes out right, even if it doesn't sound right to the actor. The audience is always the final judge, and the language to which they respond is the truth as the actor sees it in the context of the play. He must tell his lie in order to get to the truth. This is the paradox that perturbed Plato and all theatre scholars up to Diderot but, whatever they say, a lie is a lie even if it's uttered in Esperanto.

Space only allows mention in this section of the Italian, Spanish, French, German, Russian and American theatrical branches which grew from the common Greek tree. Names that spring to mind, include vital twigs like the Frenchmen, Molière, Louis Jouvet and Jean-Louis Barrault, the Germans, Max Reinhardt and Berthold Brecht, the Italians, Rossi and Salvini, Russians like Grotowsky and the legion of Americans from Edwin Booth to Alfred Lunt. Also, the Irish director, Tony Guthrie, who

travelled the world in the latter half of the 20th century like a missionary. These are all relevant to the global theatre story and they prompt another Latin tag, *ex nihilo nihil fit,* nothing comes from nothing. Therefore we must conclude that the advance of dramatic theory over the years owes much to this sturdy foreign growth. You can be sure that behind these famous names, a whole echelon of unknown actors still trail adding their voices to the swell of the eternal chorus that is world drama.

Experimentation continues and solo acting styles now extend as far as the individual performer can take the medium. Improvisation has taken over to such an extent that the theatre experience is less a conversation with an audience than an outright confrontation. The performance is a gauntlet thrown down rather than a gloved hand extended, but audiences can take care of themselves and they won't take what is thrown at them, it has to be offered. Anything less is an impertinence on the part of the actor. His bread is buttered by those who attend to see and hear him, and if he is looking for a bit of jam, he'd better not bite the hands that applaud him.

The French dramatic theorist, Antonin Artaud, in the mid-Thirties, wanted to revive what he called 'sacred theatre' involving actor and audience within a rite. He saw theatre as a place of myths and magic with the director as high priest and magician but by the mid-20th century Performance Art had emerged in San Francisco and led to theatrical phenomena like Happenings, Events and so on that came under the general heading of the Theatre of Cruelty, where the audience was almost dared to enjoy itself. One can take alienation only so far.

What was being explored was what was called 'the gap between art and life' but good art down the centuries worked to close that gap by aesthetic persuasion involving some skill and not entirely relying on one person's egotistical impudence or the audience's charity. Not to mention its stamina. Some extreme presentations lasted more than five hours. Wagner might have understood, but he had a whole orchestra to play with, not to mention a cohort of big voices. Experimentation in any art is necessary if any progress is to be made, but actors always have to bear in mind that anything that happens in a theatre, is at base, and always will be, a conversation with an audience.

As Peter Brook has pointed out, the act of theatre is, on the surface, a very simple business. 'Take any empty space and call it a stage,' he says.

'A man comes in and walks across this empty stage whilst someone else is watching him, and this is all that is needed for an act of theatre to be engaged.' Others, like Sir Peter Hall, would argue for the addition of the word. He believes that all theatre begins with the word. However, he adds, 'If the theatre is only word then it is literary and boring, but silence without words surrounding it means nothing. The more marvellous the words, the better the silence.'

Add the word to the man and you have the one-man-show in the theatre. Yet to many, this convention is unsatisfying. Despite the world-wide success known by actors such as Emlyn Williams, Hal Holbrook, Roy Dotrice and Barry Humphries, going solo is not always the best career option. The solo trail can lead the actor astray. Because of its very portability, giving an ease of travel, the soloist is often away from the main centres such as London, and being away from London or New York for too long is a slow suicide for the English-speaking working actor with ambitions.

This is a pity, because the rewards, both financial and artistic, are many for the solo player. Here, actors are generally their own boss, creating their own schedules and taking a holiday whenever it suits, except that for the lucky ones, a solo tour is one long holiday. The soloist is paid to travel the world in comfort and the only price asked of him or her is to apply themselves to a performance when asked, at the risk of sea-sickness, travel fatigue or breakfast-time interviews with the press or in isolated television studios. There is also the long separation from family and friends, but at least the cheques are going into the bank in whatever currency and the soloist tells himself that the road he is on now ultimately leads to home.

The solo performer offers the audience a very individual memory for them to take home. Their complete submission to what he offers takes them to a height of theatrical catharsis not always realisable even in the very best ensembles or finest stage companies. This is because there are so many variables in the large groups, dominated by the leading players and subject to the difference in standard among the supporting cast. In the solo, however, the single actor is all the audience have got. They have to make do, and adapt, and they invariably do, which is why the player so often obtains such a total response.

The one benefit for the actor playing away from home is that it frees family and close relatives from having to see the show. It is extraordinary

how many sons and daughters dislike seeing their fathers or mothers, sisters or brothers, perform in public. This embarrassment may only be due to their fear that the said relative will dry, or do something wrong, or elicit an unkind remark from a seat near them. Perhaps it is only a dislike of seeing a loved one pretending to be somebody else? There are dangers in playing to audiences who are too near to home.

The trick when playing to foreign audiences is to start *slowly* and gradually build up in pace as the performance goes on. If it gets to the curtain in a comfortable quiet then the performer knows the foreign audience has made the journey and both have got to the end in one piece. That is what the theatre act does, it unites actor and audience, and makes them as one. That's the love that Duse was talking about.

Some languages, however, are easier than others both to hear and to speak. The actor burdened with Anglo-Saxon, envies the French their charm and precision of enunciation, the Italians their musicality, the Spanish, their range, the Americans their in-built resonance. All languages have their different colour, and it is this native hue that gives the actor's voice its difference and individuality. This is important because the voice is the actor's most crucial stock-in-trade. It can be a recognisable signature tune, and it helps if it is slightly quirky or individual, but not too much. The late James Crampsey, a BBC drama producer in Scotland, was of the opinion that there are only two voices in the theatre, the voice odd and the voice beautiful, and the actor has to take what he or she gets. They may resent not being allotted the voice beautiful but for all practical purposes the voice odd may be the more beneficial. The audience never forgets the voice that's slightly different. But then again, not too much different.

To 'get' the voice for a specific character, the actor has to work on it. There is a daily regimen. The voice is a muscle, it thrives on use, but succumbs to disuse, which is a misuse, and then it doesn't matter what language you can't speak in. One actor I know reads the editorial of his daily paper aloud every morning. His family have grown up remarkably well-informed. Another did his vocal warm-up while jogging and passers-by were intrigued thinking him very foreign, but then he was a Geordie.

Sometimes the average dressing room sounds more like an orchestra tuning up. The musical analogy is apt, because the auditory reaction to stage performance is akin to the way we respond to music, and being so,

it is often more a matter of taste than anything else. It is highly personal, not to say, intimate, because sound, being one of the senses, is sensuous. This further attests to its being the main part of the actor's weaponry. By their voices, so shall ye know them. This is often their passport to other places.

Today, by courtesy of international festivals, sea cruises, university lecture circuits and private promoters, the actor can travel the world with a play, or personal repertoire of solo pieces, entertaining people of all languages in what might be called the cabaret of the spoken word. It is indeed a matter of 'have script, will travel'. And many do, year after year. They play everywhere from luxury saloons to luxury hotels, private homes to college lecture rooms, every kind of restaurant, in public squares, churches, and in town halls. The people met on this kind of recurring odyssey must represent almost every region in the world. Round and round the Equator they go or up and down, touching both poles, until one can't see their passports for visas. It is hard work and doesn't forward a career much but it's a great life while it lasts.

For many soloists or small chamber groups, their touring stand-by is always Shakespeare. Illyria was anywhere for an hour and the Forest of Arden stretched from Jamaica to Japan. Shakespeare, like Beethoven, enjoys an international currency that has never devalued. They both make the kind of music that you don't need to understand, but you can always listen to. One famous writer, met on a ship, said he could listen to Shakespeare for hours. 'When it gets to the boring bits I just switch off and listen to the music of the words,' he said. Another wealthy passenger remarked, 'When something fine is said, we don't hear it, we feel it.'

That's why actors plunder the good writers for acting material. They want words they can *feel*. Burns in his lyric poetry and Mozart, in most of what he wrote, have this quality. Theirs is a twinship of genius. Essentially they speak the same language of the heart, and that is a tongue understood worldwide.

The other stand-by for the actor on tour around the world is the song, and many actors are pleasant singers. If, for instance, they were unable to get through to a foreign audience for any reason, it always paid to break into song, and if there is a colleague on stage at the time, even a catchy harmony. It was astonishing how this worked. People any-where will accept song at any time, and close harmony is a bonus.

For the most part, the touring actors' audience is made up of people who have been around. They are sophisticated, successful, experienced citizens of the world who had heard Mozart in Vienna, seen the National Theatre in London, heard opera in Milan, watched the latest musical on Broadway, they aren't fools. Yet, if the actor gets it right, they will sit, like children in the nursery, and allow the performers to tell them a story or sing them a song.

This simplistic analogy is apt because, 'unless you are like a child...' you can't enter fully into that phantom world the audience enters into for the price of a theatre ticket. You must leave your preconceptions, misconceptions, biases and fixed ideas with your coat and hat in the cloakroom and take your seat with an open mind to get the best out of the theatre experience. The mind is an important thing to remember to bring in with you. That is the main receiver, and from it is broadcast all that you need to know in order to get the aesthetic intention down to the heart where it will be assimilated or rejected, depending on how effective the artist or how receptive you are feeling at the time. There is nothing mechanical in this delicate process. There is no code to guarantee the success of the enterprise. You pay your money, take your seat and you take your chance. And it is all the same the world over.

Trust is the principle element in the transaction. The actor trusts the audience to turn up, the audience trusts the actor to do good work, whatever the play or the language. And there is no trust like a child's trust. Or belief. The audience may not be asked to believe in fairies, but a good deal is expected of them in the course of the night, and all they expect is a good deal in return. It is a pairing made in the box-office, but hand-in-hand, like Hansel and Gretel in the story, actor and audience can go into the forest without any fear of the Wicked Witch.

Playing out of doors on tour is always a hazard. The setting nearly always chosen is sylvan and beautiful, but it always carries with it those theatrical philistines – birds. They are not impressed by actors. No matter the breed, birds will insist on whistling through the most poignant moments and gulls will circle menacingly overhead adding their contribution to the costumes below at will, much to the amusement of the audience. Attacks come not only from above but from below. A rabbit may decide to explore the acting area, or a less pleasant rodent, especially in the Far East, can race across the performer's feet which can mean a

momentary lack of concentration, especially if the performer is an actress. It is noticed that whenever this happens all the ladies in the front row involuntarily lift their own feet on to their seats.

Lord Olivier was once heard to mutter in the wings, 'This is no profession for an adult person,' but then not all professionals are adult. Child actresses don't always survive to become adult actors. Master Betty was a famous boy Hamlet in 1804 but when he tried Richard III, it failed and he never acted again, although he lived until his eighties. However, very many young girls persevered to make good actresses and among actresses there is nothing like a Dame. Ellen Terry was among the first. She made her theatre debut as a child of nine and lived to become Sir Henry Irving's leading lady at the Lyceum and mother of Edward Gordon Craig, but not by Irving. She once gave good advice to the young Gladys Cooper during a tear-jerking scene they shared, 'Now, dear, don't be sorry for yourself. Let the audience cry – don't you cry.'

Dame Flora Robson was unusual in that she took time out from the theatre for four years returning in 1924 at the age of 22, to start all over again to become one of the cleverest British actresses. When asked by the producer of one play if she could look 16 for the part. Flora said, 'I have never looked 16, but I could act 16.' There's the nub.

Another child-starter was that great lady of the theatre, Dame Sybil Thorndyke who travelled the world in classic theatre. She tells that, as a Victorian child, she went with her mother to her first audition in London. 'In an awful room half way up a fourth-floor building in Bedford Street.' Wearing a veil, she climbed up all the stairs to be met by her auditioner, the actor, Fred Topham, who told her mother,

'I don't think I'll bother the child. She looks as if she can act.'

To which the young Sybil, throwing off her veil, retorted,

'Of course, I can act. I've acted since I was four. Anybody can act, it's the easiest thing in the world.'

Dame Sybil Thorndyke was to go on and have a stellar career in the theatre, including Shaw's original St Joan, and to found, with her husband, Sir Lewis Casson, a whole dynasty of theatre people. She continued to work almost to the end, but one wonders if she were of the same opinion about acting by then? Hardly, one would think. She died in 1976, aged 93, but still full of the energy and wit that so characterised her acting type at that time. Sir Ralph Richardson said of her,

'Like Chaplin, anything she touches comes to life.' Has there been a better epitaph?

If all the world is indeed a stage, it is just as true that for actors, their stage is a whole world. A world which waits to be populated nightly by audiences as found. Yes, 'Have script will travel' – even if it's only as far as the back row of the theatre. Which is why actors speak louder than words.

Is there Life after Acting

HISTORICAL ASIDE

The Victorian age passes to the tune of Gilbert and Sullivan Savoy operas and the flick of an Oscar Wilde epigram turned by suave actors in the more intimate theatres now building up in London's West End. Comedy is the key as the century changes. 1905: The biggest laugh is raised when Henry Irving is knighted. The profession is recognised at last. Melodramas abound all over the country and another actor-knight, Sir John Martin Harvey, tours forever with 'The Only Way', an adaptation of Dickens' 'Tale of Two Cities'. Music hall thrives and Marie Lloyd is the uncrowned Queen of Lower England. George Edwards shows off his young ladies in his Edwardian revues at the Gaiety. 1914: The first World War begins in holiday mood but ends in 1918 in an Armistice that only postpones a Second World War for 20 years.

'...He isn't the Cat that he was in his prime,
Though his name was quite famous, he says, in his time!'

'Gus the Theatre Cat' by T.S. Eliot

OLD ACTORS NEVER DIE, they just mumble away. They move into the back room of their family home or to a corner of their pub where they set up as a local entertainment industry or an engaging curio. They may even retire to the old actors' homes that Actors' Equity provides from bequests left by very successful actors of other days. What happens in Old Actress Homes is still another mystery but their commonality with actors still applies and suggests that things may be much the same. In the male quarters, the ancients will vie with each other in the size of past audiences they drew, the beauty of the actresses they seduced, the vast salaries they earned at their peak, the glowing notices they garnered but the listener knows to half or double whatever is said, the truth is always somewhere in between. Anyway, what does it all matter now, the only

thing to do for the actor in retirement is to pass the hour pleasantly and without any pain. It's not a huge ambition at any time, but in old age it is enough.

He might ponder on the fact that in his career he had never been a young Hamlet, or a middle-aged Macbeth or an old Lear, but he comforts himself in knowing how good he would have been had he been offered these parts, and he doesn't hesitate to tell his fellow-inmates so. They cap his stories with their own 'what if' and 'if only' tales and honour is served. Yet there is no regret in all this. If these men have lived a long life with a greasepaint stick in their hand looking into the mirror of their long years, they have nothing to be sorry for. They have served their time in the light, and it's good now to rest in the shadows and savour the memory of their adventures. To be an artist of any kind is to be an adventurer, for to do the work at all you have to venture, to work toward the unknown and attempt the impossible with confidence and faith. It would be hard to do if one were a clerk in an office faced with a ledger and a clock whose hands hardly moved in the course of the day.

The old actor remembers when he ran to the theatre some nights, so eager was he to get on with the magic. He was always reluctant to go back to his digs in the strange town because the audience's applause was still reverberating in his ears. He was reluctant to come back to earth, but the landlady's re-heated supper never failed to do the trick. He has spent his whole professional life making memories for other people and, in the end, it is these same memories that sustain him. This is fair enough, because he only remembers the good times with good friends in good plays in good theatres in front of good audiences. The rest is already in the amnesia bin where it belonged. When the lines became harder to learn, he turned to the old post-card trick where his lines were written on the card and he would whip it out when required saying as a cover, 'Good Lord, I forgot to post this' and carrying on with the dialogue. Old actors were wily and knew all the dodges. They had come down through all the generations.

There is a selection process in any kind of recall. That's healthy and necessary for peace of mind. Who wants to be haunted by failures? Of course, they were there but their blackness only made the pure white of success all the whiter. Most of the time, for the ordinary actor it was an acceptable grey. Even so, it allowed him a family, sometimes, more than

one, and his more obvious legacy is in the pride of young lions he has given to the world in skyscraper grandsons with university degrees and a sporting prowess he can only envy. Also a withdrawing room full of graceful granddaughters who have beauty, wit and the same athletic skills.

Not all actors are as lucky. The old bachelor actor still exists, the essential loner who travelled the country with his cigar box of make-up, his one good 'interview' suit and a couple of white shirts with a school tie to which he had no right and an address book giving the best theatre 'digs' in every town in Britain. This kind of actor spent most of his leisure time in trains, but at least it allowed him to catch up with his reading and sleeping and finish yet another crossword. These actors would get out on to the platform at Crewe and similar junctions. Here they would meet with others of their kind for a hurried conversation with old friends and colleagues in other trains going in other directions. There would be much shouting and back-slapping and all would get back on board their respective trains having caught up with all the 'dirt', as they called the gossip, and with information on the latest London auditions coming up. They were all rivals, but very friendly rivals. They were grease-paint monkeys one and all. Shakespeare's rude mechanicals brought up to date and armed with a make-up stick. In short, they were actors.

Theatrical lore of that period tells the story of two old actors who met crossing Leicester Square in London. One had his cigar box under his armpit and was carrying a pair of slippers with a faded silk dressing gown over his arm.

'Another engagement, old man?' enquired the first actor of his friend.

'Not this time, old boy,' answered the other. 'Moving house.'

Dear old Gilbert (not his real name) was one of that generation. He was a good actor, but was hardly noticed in a long, productive lifetime as a working pro. At this time, he was playing a small part in a touring production of a Sheridan play that week in Scotland. He was sharing a dressing room with a young actor, who was also playing a cameo part – on at the beginning and end of the play – but just right for someone making his theatrial debut. Gilbert's role was also just right for an actor at the end of his career, so both were satisfied. Not that anybody cared.

The play opened on the night of the Coronation of Princess Elizabeth. Gilbert said that night into his mirror. 'I think I've come full circle. I started off with a she-person on the throne and now here's another one to

rule over us. Bang goes my knighthood now.' And he chortled as his gnarled fingers dipped into his cigar box. Next day the newspapers were full of Edmund Hillary's ascent of Mount Everest with Sherpa Tensing, so nobody was talking much about a provincial touring production. Never mind, it gave Gilbert valuable dressing-room time to regale the young actor with anecdotes from his lengthy career. The young actor, at the start of his, thrilled to Gilbert's many theatre stories in the same way one can see the young boys listening in Millais' painting, *The Boyhood of Raleigh*.

In addition to the little silver whisky flask which he always carried (*'Strictly medicinal, old chap'*) Gilbert always travelled with an old framed photograph which showed an old actor kneeling foreground and a young actor, sword in hand, all curls and gleaming eyes and teeth coming in at a window behind him.

'Who's the old guy, Gilbert?' asked the young actor first time he brought it out.

'That's Irving, dear boy.'

'Is it?' The young actor was impressed. 'And the swordsman?'

''Tis I,' answered Gilbert. TYA was even more impressed.

'Gosh,' he murmured but before he could say anything else, Gilbert went on,

'Still is. I'm that actor yet, same fella, same heart, same talent. The face has fallen in, the eyes aren't so good and the hearing's buggered, but that's me, my boy and I'm still climbing through that bloody window. And Sir Henry's long dead. That's the only difference between us now, eh? He's gone, and I'm still here. Treading the old boards. A bit gingerly these days, but at least, I'm on me feet, what?'

And he chortled to himself again as he applied the finishing touches to his make-up, the ancient face less than half-an-inch from the mirror. Young as he was, TYA understood what the old man meant. Gilbert carried within himself yet the continuity of the acting instinct he himself had inherited nearly a hundred years ago. What a pedigree, a line that goes all the way back to Thespis. No wonder he was proud to be an actor. It offered him a life-giving energy. This is what kept men like Gilbert young. Even if his body was gradually giving up on him, he never gave up on it. He defied it to close down. He willed it to work.

The young actor had to help him down the two flights of spiral stone steps from the dressing room to the wings and would gently push him

on as the old boy's cue came up. His arrival on stage was a signal for great games among the rest of the cast. Some of them would repeat his lines, laughing as they did so and others would walk round him teasing throwing him cue after cue in quick succession till the old fellow was bewildered and could only stammer out what lines they gave him room for. It was an appalling show of professional bad manners, and untypical of the company generally but there were a couple of clever dicks in the cast and they saw it as an opportunity to show off.

The humour of post-Restoration comedy derives more from situation than dialogue, and like much of Sheridan relies on a stylish, rapid-fire delivery on the part of the actors. Gilbert may have been a little slow in responding to his cues and this might have led some actors to come in quickly and finish his line for him. This is what became the game, and the evening sport for the young bucks surrounding him. It was no more than verbal horseplay and a bit of fun but watching it made the young actor angry and his heart broke for Gilbert. TYA looked round at the stage manager standing behind him, but he only shrugged and gave nothing away behind his glasses. The audience had no idea what was going on and took it all as typical period piece pranks.

When the curtain came down at the end of the act everyone ran past the young actor in the wings as he waited for Gilbert to hobble off. There wasn't much said as they went back up the stone stairs. TYA hadn't the heart and Gilbert didn't have the breath. As soon as he was settled in his chair, Gilbert took a little sip of 'medicine' and said, 'Went quite well, I thought. Scene just flew by.'

Just then the young actor's call came on the tannoy and he was glad to leave the room. He would make sure they wouldn't try their tricks on *him*. The small part he played allowed him to be stealthy. He played it like a cat, and out-foxed them. When he got back to the dressing room, old Gilbert was gone.

He was allowed to miss the curtain call but it seemed he had collapsed at the stage door and a taxi took him to his digs. He was found dead there next morning by his landlady. A young ASM took over the part till they found an actor to take the role for the rest of the tour. Nobody noticed any difference except that the same actors did all they could to help the ASM get through the night. Perhaps they were shamed or maybe they were doing it for Gilbert.

That night, the young actor cleared Gilbert's dressing space. It didn't take long. He put the few bits of make-up back in the cigar tin and closed the lid on the remover cream. There wasn't much else to clear and there was nothing left in the whisky flask. He wrapped it all in the grubby hand towel and put it in the Gladstone bag Gilbert always carried. The last thing he put in was the Irving picture. He took it down to the Stage Manager as he was leaving. The Stage Manager looked in the bag and said without any great interest,

'Nothing much here. Just chuck it.'

'But what about Gilbert's family?'

'Had none. There was a sister somewhere, where he stayed when he was resting. So the office said. He was of no fixed abode, like most of the old school and no next of kin, poor old sod.'

'There was a picture of Irving – ' the young actor began.

'That right? Look, it's time we were out of here.'

'But what about – '

'Please yourself, kid. I'm off. Remember there's a matinee tomorrow. Good night.'

'Good night.'

And that's how the young actor came to have the picture of Henry Irving and the actor at the window.

For years, when people came into his study, they would see it and invariably say,

'Who's that?'

'Sir Henry Irving.'

'Oh? And who's the young fellow in the window?'

'ME.'

Another kind of window has opened for actors in recent years. A whole new talking industry has developed within the big corporations and finds its expression in expensive hotels or country lodges where lofty executives are turned in upon themselves by actors who have been turned in on themselves for most of their lives. International money is available to help actors help middle-aged men and women face their audience from the podium at an annual meeting or cope with matching suits facing them from matching board room chairs. They have all discovered late what the actor has always known, that life is one big bluff, and that day-to-day survival in the world depends not on what you say or do but

what the other person thinks you are saying, and if he believes that you really are doing what you seem to be doing.

Big business has discovered show business and the actor now sets out his stall in five-star surroundings. He explains to titans of industry that it's all a matter of management, but not of staff or the workplace or plant, but of their own bodies and basically comes down to a matter of correct breathing. After all, this is all that life requires, that you keep breathing. People take breathing so much for granted that they forget all about it and only think of it where there is a possibility that air to the lungs may be threatened or even cut off. Then what they do is take a huge breath of relief. However, to make the most of life, whatever your job is, you should learn to take in more breath and give out less. It's the first rule of body management, to learn to breathe. This is the basic trick that allows an actor to face any audience in the eye, and even himself in the dressing room mirror. Air is the main energy provider, take in plenty of it, especially if it is fresh and clean, and let it out sparingly.

Time is the second acting commodity, and taking it is the next lesson to be learned. There is a lot more time available than people allow. Commercial activity is so concerned with schedules, programmes, end-dates and meeting times that the very thing they need most, time, is the commodity most wasted in chasing impossible deadlines. There should be time in every day to stop, step back, take stock and think. Thinking time is a luxury when it should be the essential element in any corporate structure.

The actor is trained to this because of his need to study texts in private in order to commit dialogue to memory. This facility should be sought by anyone who wishes to master rhetoric, the first tool of the politician, the leader and the confidence trickster. All of these know the importance of the right word, carefully chosen and skilfully delivered. All the great orators knew this, especially at the opening of their perorations. Adolf Hitler, one of history's arch-criminals according to his political record, was a master speaker, despite a frequent descent into hysteria at his climaxes, but watch his openings. See in your mind's eye, the massed array of his machine drilled audiences laid out with immaculate precision in the sports arena. He is a tiny figure on the platform but minutely prepared for gigantic sound amplification. He stands for a moment looking out on the immense stadium, pauses for ever it seems, then he spreads his arms and says very quietly, 'Kameraden'.

It is a masterstroke of timing and effect. It is acting. 'Comrades' he calls this vast, faceless assembly, and every single person there feels he is addressing them personally. The actor has to try to achieve this effect each night with an audience. He knows from experience that to have the courage and confidence to wait before you speak is to get off to a winning start. One can never over-estimate the importance of the pause. More is said in the theatre by a filled silence than by a string of empty words. Pause and effect is the formula.

Self-confidence breeds confidence in others but over-confidence can just as surely repel. Peer pressure is another obstacle, but the biggest businessmen in the world are always, at heart, boys in the playground.

These helter-skelter chasers fail to see the need for appropriate study and rehearsal. They have to read things other than statements of accounts and business plans. The aesthetic is as vital an element as the statistic in the complete man's communicative equipment. If he is thoroughly rounded, he need never be intimidated by office or rank or position. It is never the status of the listener that the speaker has to impress, but the person holding it. The thing to bear in mind at all times is that the most prestigious, superior person in the room also went to the lavatory that morning.

The final, and often the initial, link between theatre and the business world is the backer or 'angel' who provides the funds with which to mount the play or musical. These funders can range from mighty corporations to a pensioner with some money in the bank but what they have in common is a fascination with the whole theatre process and a desire to assist in an way to make it all happen. All producers have their little lists of such people and you can be sure recourse is made to every name when production time looms. Angels, whatever their size of wing, are regarded as manna in troubled times. Some investors have made fortunes and others have lost everything. It's all part of the theatre thrill. And when the risk fails yet again, the angels involved are assured that they have made a great contribution to Art and that their reward will be great in Heaven.

The Play's the Thing

HISTORICAL ASIDE

The 20 years between the two world wars were good for some but bad for most as the international depression sank in, but theatre always thrives when conditions are poor and it was a time for bold experiment and change. 1924: 'The Vortex' makes actor/ playwright, Noel Coward a star. He seemed to write a play a week and in 1925 he has five productions of his own plays on in London. He typifies the flapper era. The other face of the same coin is provided by John Gielgud whose role as 'Richard of Bordeaux, announces the arrival of a poetic actor whose Hamlet is said to be the finest of his generation. Both performers were eventually knighted for their services to theatre, the delay due to their known homosexuality. Yet their names dominate this period and today there is a Noel Coward theatre in London.

THE ACTOR'S PHYSICAL REPERTOIRE is a whole box of tricks but these are available to everyone if they care to open the lid. In the heat of the meeting, the businessman is the actor in performance. He has to avoid any extraneous tensions, remain alert, listen out for his cue, be ready to rise and speak up, taking care not to knock over the glass of drinking water. He is the only one who can hear the beating of his own heart. He must pretend a calm he doesn't feel and he can achieve this by rehearsing his material assiduously beforehand. This can best be done by speaking it ALOUD either at home, or in the hotel room, or even in the crowded railway carriage. He must attain the actor's imperviousness to the stare. Or to the convenience of others. One famous contemporary playwright even *wrote* some of his best lines on the loo, and thought up his plots while having a very long bath.

Above all, the public speaker must remove from his utterance, that staple of American business-speak, the 'UHM', which is inserted like commas in so many otherwise erudite and important statements. The

UHM is not only evidence of a lack of preparedness but it impedes articulation. It forgets that the most important agent in the act of communication is the listener, as has already been pointed out with regard to the place of the audience in the theatre. And yet, as the actor knows, the ultimate communication between two parties is complete silence but at a business meeting this might be difficult to put into the minutes. It could lead to an entry reading, 'at this point nobody said anything'. Who knows, that silence could be telling.

It used to be said that keeping up one's appearance each day was a daily gift to other people but now it can almost be seen as a threat, for we live today by the image, and that image may be entirely false. At least when Snug the joiner was pressed to play the Lion in the play within the play in *A Midsummer Night's Dream,* he knew he wasn't really a lion. As he said, 'If you think I am come forward as a lion, it were pity of my life; no I am no such thing; I am as other men are...'

Unfortunately, the modern image self-builder believes in his expensive and superficial incarnation. He thinks he *is* what the press release says he is, which is why we have so few statesmen in politics. Politicians are no more than justifiers of the words put into their mouths often *before* they have taken political action. Expedience rules, there is no thought for consequence, either for the state or humanity. The only need is to be re-elected. Even then, they are chosen more for their appearance than for their capacity. Why don't they join Actors' Equity and be done with it? After all, there is a precedence. An American actor became President of the United States, and another, a German, became the unlikely Governor of the State of California, but that's California.

As Harold Rosenberg states in his excellent *Act and the Actor,* 'Washington acts by putting on an act. The same is true of every state capital and city hall. With sheriffs behaving like movie actors, movie actors aspire to the highest office.' As we know, what America does today the rest of the world will do tomorrow, or the next day at the latest. So far, in Europe, only Poland has boasted an artist as president and he was a pianist, but English Oscar-winner, Glenda Jackson, did become a British Member of Parliament and has maintained a modestly impressive profile ever since. She would have no problem with her words. And that's where it all starts.

It is the word, and how it is used, that is the final decider. Thomas

Hobbes, the Elizabethan philosopher, held that, 'words are the wise men's counters, they do no reckon by them, but they are the money of fools.' Siegfried Sassoon put it more poetically when he wrote.

'Words are fools
Who follow blindly once they get the lead,
But thoughts are kingfishers that haunt the pools
Of quiet. Seldom seen...'

'Words, words, words' as Hamlet put it, are the sole ammunition of the phoneys, yet how much of Churchill's effectiveness as war-time Prime Minister was his magnificent handling of the spoken word. At one point, his oratory was Britain's only defence against Nazi supremacy. President Roosevelt's popularity in the same period was largely due to his mastery of the intimate radio 'fireside talk'. These men were used to command but they weren't afraid to use their softer side in order to persuade. This is what women do so well and the strong male is more than happy to use the feminine side that is in him when required. Actresses, on the other hand, command by utilising the male part that is within them.

Actors use their feminine side when they attempt to persuade an audience, not the harder power which is only bullying and that has never been known to win over anyone. All performers know that words combine to make thoughts and thoughts in turn create feelings, and it is the pursuit of feeling in the hearer, which is the first and last intention of the actor in the theatre. To use Robert Nye's phrase, they are the 'entrepreneurs of identity'. They will 'sell' you anybody except themselves. But it is always the self at the control panel.

No audience can be coerced, no matter the volume hurtled at it. Young audiences respond at pop concerts not to the noise but to rhythm and there is innate rhythm in all speech and overt rhythm in good speech. Some people only speak with the outside of words, not realizing that words have an inside, too, that has to be expressed if their full value is to be realized. And full value is what the actor seeks in every word.

All the actor wants in return is a response, a reaction, which manifests itself in the emotional involvement of the audience. Everything done points to this aim, and every aid available in theatre practice is brought to bear on its attainment. Whether it is the playwright with an efficacy of the spoken line, the designer with a significant use of colour or a deft

placing of furniture, the electrician with lights or the sound technician with a strategically placed microphone, the actor is assisted at every stage. In business terms, they are all part of the theatrical 'out front' and back-stage teams brought together by the chairman of their company, the producer, complemented by the managing director, the theatre director, assisted by his various heads of department who have staff under them, the stage management. They all serve the sales division, the actors, who are the only ones to deal directly with the customers, the audience, via the sales pitch, which is the play. In the end, it's the only thing.

The Greenroom in the Sky

HISTORICAL ASIDE

The post-war period in the theatre is dominated by Laurence Olivier who was not only knighted for his services to theatre in 1947 but also elevated to the peerage in 1962. As Lord Olivier, he heads the first National Theatre Company at the South Bank, directing Peter O'Toole as Hamlet. But it was the last trump of an older style and the waste land of the atomic bomb was reflected in Samuel Beckett's 'Waiting for Godot' (1953). This was premiered in Paris before coming to London in 1955 directed by Peter Hall. This bleak enigma of a play set the tone for the modern age. Harold Pinter followed with 'The Birthday Party' in 1958, another puzzle play and London's West End surrendered to Lord Lloyd Webber and the tyranny of mammoth musicals created primarily for the benefit of foreign tourists.

CHARLES BABBAGE WAS AN English Early Victorian eccentric who had an indefatigable detestation of street organ grinders and a genius for numbers. He was responsible for the first bulky, but workable, mechanical calculator even though he never finished building it. He was an authority on logarithms and a professor of Mathematics at Cambridge but, what he is less known for, is that he believed that sounds made by the human voice never died but persisted as a kind of cosmic energy and floated up into the ether to be stored there forever. It was this theory that suggested the idea of the Green Room in the Sky where all the voice sounds made by actors from Thespis to Olivier are still reverberating to their own delight as well as to that of their peers long gone, or recently added to their celestial company. As John Keats wrote in a blank page of a printed copy of Beaumont and Fletcher's, *The Fair Maid of the Inn,*

'Bards of Passion and of Mirth,
Ye have left your souls on earth!
Have ye souls in heaven too,
Double lived in regions new?...

Thus ye live on high, and then
On the earth ye live again;
And the souls ye left behind you
Teach us, here, the way to find you,
Where your other souls are joying,
Never slumber'd, never cloying.
Here, your earth-born souls still speak
To mortals, of their little week;

Keats was speaking of poets, but he might well have been be speaking of weekly rep, remembered by so few today. What a lovely thought it is that all those beautifully produced stage voices may still be trilling somewhere in space, keeping alive in one vast aural archive a long, illustrious lineage, if only for the edification of passing Martians or strayed astronauts. What would they make of Burbage's West Country accent as the original Hamlet, or tiny Garrick's greatness in most things he did, despite Goldsmith's sly comment in *Retaliation* (1774),

Like an ill judging beauty, his colours he spread
And be-plaster'd with rouge his natural red.
On the stage he was natural, simple, affecting;
'Twas only when he was off he was acting.

The same might be said of many, except perhaps the incendiary Edmund Kean, whose fires could never be put out unless by a large quantity of whisky, and a good malt at that. Macready would be glad to be rid of performing at last and could freely indulge his love of interminable pauses. Probably this eminent Early Victorian would sulk a bit. He is the only actor I know of who didn't enjoy being an actor. Would Irving's magnetism in *The Bells* draw the stars to him? Or John Martin Harvey's noble end in *The Only Way* stand him in good stead? Or Gerald du Maurier's stage naturalism, Noel Coward's clipped facility in comedy, John Gielgud's beauty of voice in everything, Ralph Richardson's idiosyncratic Peer Gynt, the pensive Michael Redgrave in Chekhov, Laurence Olivier's spidery Richard III?

The list is endless, and every one of them worthy of their adjectives. What a vocal treasury it would be – a monster transmission. On the air in every sense, and though heard but not seen, they would be *real* stars

at last. I'm sure Donald Wolfit's Lear could still be heard from earth on today's sophisticated listening equipment and no doubt, Michael Williams' charming vocal delivery still lingers somewhere in the astral plane.

All this of course is mere fancy and the above names are from the top of my head, or from my theatre reading, my professional memory and from what other actors have told me, but what a fascinating Babbagescape they suggest – the voice of the actor down through the ages, a magnificent symphony of the spheres with every voice a soloist. And when not in full voice, actors would be in conversation with each other, as risqué as Heaven would allow, but Heaven for all actors. I can just see Michael sitting comfortably in the celestial greenroom deep in conversation with Shakespeare and Rob Wilton at the same time and Lord Olivier will no doubt be button-holing Garrick about some detail of performance written up in the latter's famous notebook. There would be endless and joyful discussion among all these stage-struck 'names'.

The distaff side would be as well represented from Mrs Siddons to Dame Sybil Thorndyke via Ellen Terry and their alto and soprano section would make the histrionic choir all the more musical. Such actresses were able to make themselves heard above any of the male thunderers of their time so it might be supposed they could do likewise in the beyond time, if that is how we can think of the hereafter. Actresses had to fight as hard for their place on the stage as they had for the vote so they are not likely to give way to mere volume.

Every good actor is remembered by someone somewhere. It is this memory of a performance that passes on to the next generation and the next and the next until virtual immortality is imposed by word of mouth. True fame is always posthumous, for with the acting greats, the good lives after them, only their poor notices are interred with their bones. Reputations have been made in the grave as work is re-assessed in the light of modern knowledge, but how can posterity possibly judge the effect of an inflection, the sound of a sigh, the timing of a pause to get the laugh and all the other tricks the actor learns in his time in order to hold an audience *at that time.*

This is the vital point that bears iterating, that the only tense in the theatre is NOW. Like life itself it is only realised in the breath as it is taken. Awareness is no more than that. Mind and matter are joined in an acute consciousness that makes one of any audience. Its very evanescence

makes it hard to capture at will. It can take months of work to make a moment in the theatre. Which is why it has to be appreciated even as it happens. Good theatre is a treasury of such moments brought to us by an army of greasepainted angels down the centuries who fly on the wings of the spoken word, straight from the scripted page and right into our hearts. And as the good Book tells us, 'Where your centre is, there will your heart be always.' It's a fierce responsibility for any artistic tradesman to deliver on cue just the right hint of emotion with the concomitant precision of the scientist, but that's just what the actor at work does. He absorbs and emits quanta of energy. He can change before your very eyes, turning upstage as one character and turning back as another. He is the last of the alchemists, changing the lead of our petty self-concerns into the pure gold of our togetherness. By what he does, he makes you *feel* that you are part of a much bigger plan, and you had better believe him. Nothing speaks more for the actor than Edmund Kean's last words. He had collapsed on stage after the curtain had come down, following a performance as Othello at Covent Garden on the night of 25 March, 1833. As Charles Kean, his son, who was also in the cast, held his father in his arms, the audience could be heard, roaring for the famous actor. Kean said simply to his son,

'I am dying – speak to them for me.'

Theatre offers us a place where people can grieve safely as well as celebrate circumspectly. This is what catharsis offers the audience, where the safety valve of the false emotion presented as real, allows the real emotion to be felt, if only for a moment. This is why the audience is 'kept in the dark', so to speak, so that they may know a private intimacy freely in a public place.

This book has tried to speak for all actors in every age, but perhaps, in the end, acting should not be demystified but remain the worshipful mystery it has always been in the theatre, that is its temple. At any given moment in life we are all an audience at our own play, but what we have also to remember is that we are also the entire cast.

Curtain

An Actor's Apologia

THE FOLLOWING WAS WRITTEN on the morning of Saturday 15 February 2003, by John Cairney, to be recited by him at a concert to be given that evening in the St Luke's Church, Maidenhead, Berkshire, in aid of the Montgomery Holloway Music Trust by arrangement with Clare Brotherwood.

I am by profession a liar,
A fake, I dissemble and cheat
And pretend in a false situation
To be what I'm not, just to eat.
It's what I do for a living,
Though it's never as real as it seems
I deliver on cue
A moment that's true,
I offer the audience, dreams.

Their willing suspension of disbelief
Is something the actor relies on,
That they will believe whatever he says
And accept whatever he tries on.
Elbow-strangers, they meet as one
To share the cathartic joy
They will know by the end
If they but attend
To his every actor's ploy.

His work is their play
Delivered with ease and flair
By one whose practised deception
Can fill the empty air
With mind-pictures for all to see
Who have the imagination
To follow his lead
And pay no heed
To his blatant fabrication.

The actor knows he is just a part
Of an intricate theatre plan
Drawn up by the dramatist, living or dead,
To help him do what he can
To hold an audience in their seats
For as long as he needs to tell
The tale at hand
And understand
It's their story as well.

Directors and designers may do good work
In lifting the work from the page
But in judging it, we only see
The actor on the stage.
He's the mirror held up to Nature
It's ourselves in the actor we see.
Whether present or past
He will play as cast
'To be or not to be'.

'Words, words, words,' as Hamlet said
To Polonius in the play,
But even Shakespeare knew for a fact
That we don't always mean what we say.
Even in life as well as on stage,
There are always two faces on show
The one that we are
But plainer by far
Is the one we want others to know.

The actor's image is as per script,
He shapes and presents it as one
Who's given over entirely
To see the job well done,
The experience offered on the night
To all who might hear and see,
Which is why they thank
This mountebank
And do not begrudge him his fee.

A word, a look, a turn, a gesture
Any or all of these,
Can lift an audience to its feet
Or bring it to its knees.
Every actor knows this power,
When he has to play his part
Speaking or playing
Singing or saying
It must *seem* to come from the heart.

It is artifice as dramatic art,
Mummery with effect
A simple communication
Immediate and direct.
Of course nothing is that simple
There's a complex transfer of thought,
Creativity is a gift
And can't be readily bought.
It's tragic
That magic
Doesn't always come when sought.

The actor cannot be taken as read,
At his best, he is something unique,
For he links us all to a higher plane
By just being able to speak
The truth or however he sees it
In particular speech as given
Spoken well,
He can give us Hell
Or lift us up to Heaven.

It's a faculty can't really be learned,
You've got it or you've not.
And if you have it, you use it,
For that's the actor's lot.
A voice for hire, body for sale,
Theatrical prostitution
But for its cause,
And to applause,
He makes a full restitution.

That's the truth, but 'What is Truth?' asked Pilate.
Jesus didn't reply.
Not a single word. Yet He was the Word,
The Word that cannot lie.
God knows actors pray,
To do their best, on the whole
They'll always try
With their kind of lie
To reach out and touch the soul.

So let's re-consider the actor
And ponder the worth of that name
There's more to him than seems
He carries a lot in that frame,
Our messenger to the Gods,
The Herald of all things bright.
From Him comes the spark
That lights up the dark
To *His* word, *His* truth and *His* light.

In the end, it comes down to silence
Where nothing remains to be said,
Where the echo of laughter has faded
And every tear has been shed,
Only the sound of a tip-up seat
Reminds us that people were there
Now they are gone,
The curtain is down
But voices still haunt the air...

But the memory lingers on.

With this in mind, this actor's last words are an offer of thanks to all the different audiences that have carried him through so many working hours in the theatre.

CONFITEOR HISTRIONUM

I believe in the Upper Circle Gods,
Where, supported on moulded wings,
Balcony angels abound, to give praise
By shouts and loud hurrahs
To us, who act below them
In the course of plays.
And in the tier below, suitably Grand,
Are those of slightly greater means
Who, from the bench removed
Are upholstered to spectate
The passage of dramatic scenes
From a kinder, closer view.
Fauteuils, where in armchair ease,
Patrons may recline with pride
To witness from the stalls the act,
The scene seen just above their heads
In our painted world, eye-view wide.
Finally, in gilded boxes either side,
Politely shaded from the common gaze,
Those to whom we all pay homage
As is their right, who pay the most
And thus sustain our days.
Blessed be all in whatever guise,
Our nightly labours thus attend,
For them we struggle to be wise
Because they are our beginning and our end.

Selected Bibliography

Agate, James, *A Shorter View of the English Stage*, Harrap, London 1926.

Bentley, Eric, *The Theory of the Modern Stage*, Penguin, London 1968.

Billington, Michael, *The Modern Actor*, Hamish Hamilton, London 1973. (Editor) *Performing Arts*, Macdonald, London 1980.

Billington, Sandra, Dr, *A Social History of the Fool*, Harvester Press 1984.

Blakelock, Denys, *Advice to a Young Player*, Heinemann, London 1957.

Braun, Edward, *The Director and the Stage*, Methuen, London 1982.

Brewster's Theatre Dictionary – (Foreward by Peter Ustinov) Cassell for Market House Books, Aylesbury, England 1994.

Brook, Donald, *The Romance of the English Theatre*, Rockcliff, London 1946.

Brown, Andrew, *Drama* – An Arco Handbook, London 1962.

Bruce, George, *Festival in the North*, Hale, London 1975.

Burns, Elizabeth, *Theatricality*, Harper, London 1972.

Cairney, John, Dr, *The Man Who Played Robert Burns*, Mainstream Publishing, Edinburgh 1987
East End to West End, Mainstream Publishing, Edinburgh 1988.
Solo Performers, McFarland & Co, Jefferson, North Carolina, 28640. USA and London 2001.
Scottish Theatre – BA Degree Thesis, Glasgow 1986.
A History of Solo Theatre, M.Litt Thesis, Glasgow 1988.
The Theatrical RLS, PhD Thesis, Wellington, NZ 1994.
An Actor Declares – Article – Scotsman, Edinburgh 1962.
One Man in His Time – Article – Drama Magazine, BTA, 1979.
Working the Monopolylogue – Article – The Stage, London 2009.

Callow, Simon, *Being an Actor*, Methuen, London 1984.

Cheney, Sheldon, *New Movements in the Theatre*, Mitchell Kennelly NY 1914.
The Theatre, Tudor Publishing, New York, USA 1941.

Clinton-Baddeley, V.C., *All Right on the Night*, Putnam, London 1954.

Cole, Toby and Chinoy, Helen K (Editors) *Actors on Acting*, Crown Publishers, New York 1970.

Coquelin, Constant, *The Art of the Actor*, Allen and Unwin, London 1932.

Curtis, Anthony, *The Rise and Fall of the Matinee Idol*, Weidenfield and Nicolson, New York 1974.

Dale, James, *Pulling Faces for a Living*, Victor Gollancz, London 1970.

Downs, Harold, *Theatregoing*, Thrift Books, London 1951.

Donaldson, Francis, *The Actor Managers*, Weidenfeld and Nicolson, London 1970.

Duerr, Edwin, *The Length and Depth of Acting*, Holt, Rinehart and Winston, New York 1962.

Findlater, Richard, *The Unholy Trade*, Gollancz, London 1952.

Funke, Lewis and Booth, John E. (Editors) *Actors Talk About Acting*, Discus Books, New York 1963.

Granville-Barker, Harley, *Prefaces to Shakespeare*, Batsford, London 1930. Re-printed in two volumes 1958.

Hall, Peter, *Peter Hall's Diaries* (Edited by John Goodman), Hamish Hamilton, London 1983.

Hartnoll, Phyllis, *The Oxford Companion to the Theatre* Oxford University Press 1951 (third edition 1967)
A Concise History of the Theatre, OUP 1984.

Harwood, Ronald, *A Night at the Theatre*, Methuen, London 1982.

Hayman, Ronald, *The Set-Up*, Eyre-Methuen, London 1973.

Hazlitt, William, *On the Theatre*, (Edited by William Archer and R.W. Lowe) London 1895.

Herbert, Ian, (Editor) *Who's Who in the Theatre* (17th Edition) with Catherine Baxter and Robert E. Finlay, Gale Research, Detroit, Michigan, USA 1981 and London 1983.

Hobson, Harold, *The Theatre Now,* Longmans, Green, London 1953.

Hunt, Leigh, *Dramatic Essays,* (Edited by William Archer and R.W. Lowe) London 1894.

Hutchison, David, *Modern Scottish Theatre,* Molendinar Press, Glasgow 1977.

Kitto, H.D.E., *Form and Meaning in Drama,* Methuen, London, 1956.

Lumley, Frederick, *Theatre in Review,* Richard Paterson, Edinburgh 1956.

Mackenzie, Compton, *Rogues and Vagabonds,* Macdonald, London 1967.

Mackie, Albert (Editor), *The Edinburgh Gateway Company,* St Giles Press, Edinburgh 1965.

Macleod, Joseph, *The Actor's Right to Act,* Lawrence & Wishart, London 1981.

MacLennan, Elizabeth, *The Moon belongs to Everyone,* Methuen, London 1990.

Marks, Claude, *Theatre Sketchbook,* Amber Lane Press, Ambergate 1982.

Marriott, J.W., *The Theatre,* Harrap, London 1931 revised 1945. *Modern Drama,* Nelson, London (undated)

McDonald, Jan, *The New Drama,* Macmillan, London 1986.

McGrath, John, *A Good Night Out,* Methuen, London 1982.

Moffat, Alistair, *Festival Fringe,* Johnstone and Bacon. Edinburgh 1978.

Nagler, A.M., *A Source Book of Theatrical History,* Dover Publications, London 1952.

Nicoll, Allardyce, *British Drama,* Harrap, London 1925. *World, Drama,* Harrap, London 1949.

Olivier, Laurence, *On Acting,* Weidenfeld and Nicolson, London 1986.

Priestley, J.B., *The Story of Theatre,* Rathbone Books, London 1959.

Redgrave, Michael, *The Actor's Ways and Means,* Heinemann, London 1953.

Rendle, Adrian, *So You Want to be an Actor?* Black, London 1986.

Richards, Dick, *The Curtain Rises,* Leslie Frewin, London 1966.

Rigg, Diana, *No Stone Unturned,* Elmtree Books, London 1982.

Rosenberg, Harold, *Act and the Actor,* Meridian Books, Canada and
USA, 1973.

Short, Ernest, *Introducing the Theatre,* Eyre and Spottiswoode,
London 1949

Snell, Gordon, *The Book of Theatre Quotes,* Angus and Robertson,
UK. 1982

Styan, J.L., *Drama, Stage and Audience,* Cambridge University Press
1975

Trewin, J.C., *Theatre Programme,* Muller, London 1954.
The Theatre since 1900, Dakers, London 1950.

Wagenknecht, Edward, *Seven Daughters of Theatre,* Da Capo Press,
NY 1964

Williamson, Audrey, *The Bristol Old Vic,* Garnet Miller, London 1957.

Wilson, A.E., *Post-War Theatre,* Home and van Thal, London (undated)

John Cairney's Selected Credits

Theatre

King Humanitie in *The Thrie Estaites,* Assembly Hall, Edinburgh
 Festival 1959.

Hamlet in *Hamlet,* Glasgow Citizens' Theatre, 1960.

Rashleigh Osbaldistone in *Rob Roy,* Lyceum Theatre, Edinburgh 1962.

Captain Absolute in *The Rivals* at the Lyric, Hammersmith 1963.

Cameron in *The Sleeping Clergyman,* Glasgow Citizens' Theatre, 1964.

Tony Perelli in *On the Spot,* Connaught Theatre, Worthing, 1969.

John James McPhee in *Random Happenings in the Hebrides,* Her
 Majesty's Theatre, Aberdeen 1970.

Archie Rice in *The Entertainer* at Dundee Repertory Theatre, 1972.

Cyrano in *Cyrano de Bergerac,* Theatre Royal, Newcastle, 1974.

Charlie McGrath in *Willie Rough,* Lyceum Theatre, Edinburgh, 1972.

Ivor in *The Ivor Novello Story,* Cottage Theatre, Cumbernauld, 1974.

Thomas Becket in *Murder in the Cathedral,* St Giles' Cathedral,
 Edinburgh Festival, 1986.

Lord Burghley in *Mary Stuart,* Assembly Hall, Edinburgh Festival,
 1987.

Macbeth in *Macbeth,* Inchcolm Island, Edinburgh Festival, 1989

C.S. Lewis in *Shadowlands,* Court Theatre, Christchurch, New
 Zealand, 1992.

Television

Bramwell Bronte in *Wild Decembers,* BBC London 1956

Edgar Allan Poe in *The Nightmare Man,* BBC London 1956

Bothwell in *Fotheringay,* BBC Glasgow 1959

Alan Fairford in *Redgauntlet,* BBC Glasgow 1959

Tom Donnelly in *Mr Gillie*, BBC Glasgow 1960

James Durie in *The Master of Ballantrae*, BBC Glasgow 1962

Tim O'Shea in *Dr Finlay's Casebook* BBC London 1963

Jack Pelham in *Emergency Ward Ten*, ITV London 1965

Jack Taylor in *Danger Man*, ITV 1965

Ian Craig in *This Man Craig*, BBC Glasgow 1966–67

Robert Burns in *There Was A Man* BBC 1966

Firth in *The Avengers*, Granada TV, 1969

Robert Bruce in *Jamie*, ITV London 1971

Sir James Melville in *Elizabeth R.*, BBC London 1971

Jenkins Brothers (Twins) in *The Persuaders* ITV 1972

John Mackie *Scotch on the Rocks*, BBC Glasgow 1973

McGonagall in *McGonagall,* STV Glasgow 1977

Ivor Novello in *The Ivor Novello Story*, STV Glasgow 1977

Charles Rennie Mackintosh in *Mackintosh*, STV Glasgow 1977

The Earl of Douglas in *Henry IV Part I* BBC London 1979

Robert Russell in *Taggart*, STV Glasgow 1986

Henry Duggan in *Marlin Bay,* TVNZ 1994

Trapper in *The Nightmare Man*, TVNZ 1997

Film

Elias in *Ill Met by Moonlight*, Rank Organisation/Vega, London 1957

Tom Nichols in *Miracle in Soho*, Rank Organisation, London 1957

Jan Vidal in *Windom's Way*, Rank Organisation, London 1957

James Creigh in *It's Time For Me To Go Now*, MCA, 1958

Patrick Murphy in *A Night To Remember*, Rank Organisation, London 1958

Michael Callaghan in *Shake Hands With the Devil*, United Artists/Troy 1959

Gunner Willie Ross in *Operation Bullshine*, ABPC, 1959

Chris Jackson in *The Flesh and the Fiends*, Regal/Triad Films, 1960

Larry in *Marriage of Convenience*, Anglo Amalgamated Films, 1960

Detective Bridie in *Victim* Rank/Allied/Parkway, 1961

Hylas in *Jason and the Argonauts*, Columbia/Worldwide Films, 1963

Phoebus in *Cleopatra*, 20th Century Fox, 1963

Harry in *Devilship Pirates*, ABP/Hammer Films, 1963

Michael Osborne in *A Study in Terror,* Rank Organisation, London 1965

Luath Press Limited
committed to publishing well written books worth reading

LUATH PRESS takes its name from Robert Burns, whose little collie Luath (*Gael.,* swift or nimble) tripped up Jean Armour at a wedding and gave him the chance to speak to the woman who was to be his wife and the abiding love of his life. Burns called one of 'The Twa Dogs' Luath after Cuchullin's hunting dog in Ossian's *Fingal.* Luath Press was established in 1981 in the heart of Burns country, and is now based a few steps up the road from Burns' first lodgings on Edinburgh's Royal Mile.

Luath offers you distinctive writing with a hint of unexpected pleasures.

Most bookshops in the UK, the US, Canada, Australia, New Zealand and parts of Europe either carry our books in stock or can order them for you. To order direct from us, please send a £sterling cheque, postal order, international money order or your credit card details (number, address of cardholder and expiry date) to us at the address below. Please add post and packing as follows: UK – £1.00 per delivery address; overseas surface mail – £2.50 per delivery address; overseas air-mail – £3.50 for the first book to each delivery address, plus £1.00 for each additional book by airmail to the same address. If your order is a gift, we will happily enclose your card or message at no extra charge.

Luath Press Limited
543/2 Castlehill
The Royal Mile
Edinburgh EH1 2ND
Scotland
Telephone: 0131 225 4326 (24 hours)
Fax: 0131 225 4324
email: sales@luath.co.uk
Website: www.luath.co.uk